GLOUCESTER
IN
50
BUILDINGS

CHRISTINE JORDAN

AMBERLEY

Acknowledgements

As always, a huge thank you to all the photographers who have so very kindly allowed me to use their images. In particular, Tom Tunstall, Wendy Harris, Roger Smith, Ben Abel, Saffron Blaze, Ted Boucher, Kevin Branchett, Mike Broome, Andy Brown, Sarah Cocke, Harvey Faulkneraston, Jeremy Fennel, Hugh Llewelyn, Colin Manton, Roger Marks, Nick Townsend, Barry Watchorn, Mark Wheaver (mark.wheaver@englishtowns.net).
I would also like to thank the staff at Gloucestershire Archives for their helpfulness.

To the architects, stonemasons and builders who have contributed to the making of this great city.

First published 2016

Amberley Publishing, The Hill, Stroud
Gloucestershire GL5 4EP

www.amberley-books.com

Copyright © Christine Jordan, 2016

The right of Christine Jordan to be identified as the Author of this work has been asserted in accordance with the Copyrights, Designs and Patents Act 1988.

Map contains Ordnance Survey data © Crown copyright and database right [2016]

British Library Cataloguing in Publication Data.
A catalogue record for this book is available from the British Library.

ISBN 978 1 4456 5231 3 (print)
ISBN 978 1 4456 5232 0 (ebook)

Typesetting and Origination by Amberley Publishing.
Printed in Great Britain.

Contents

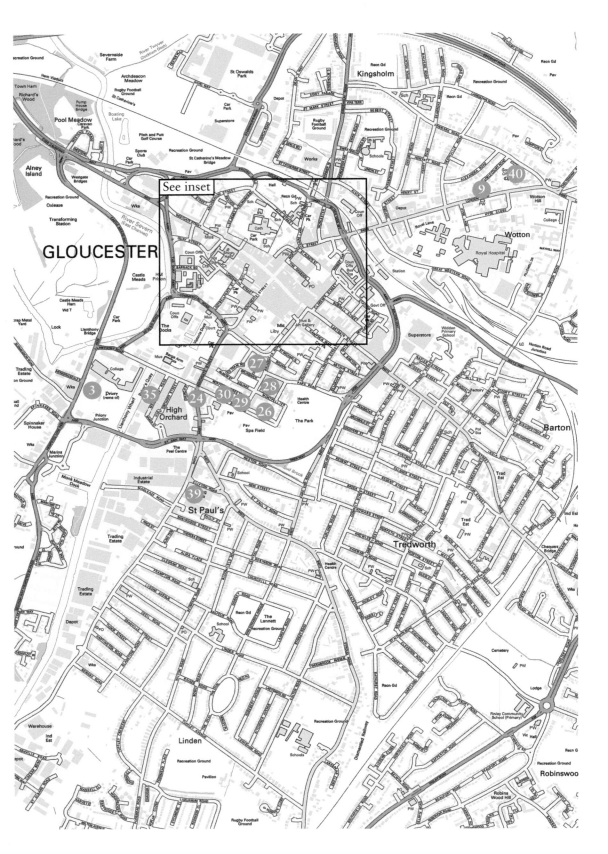

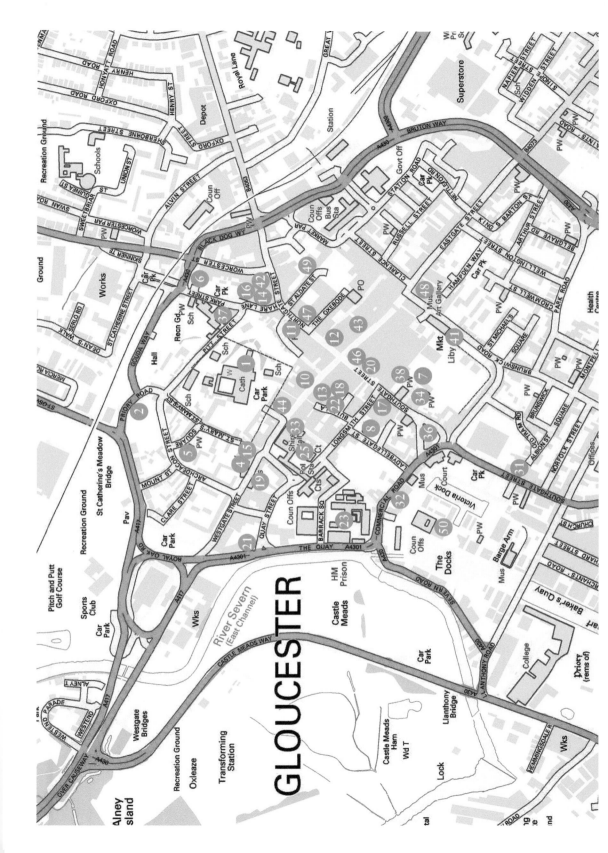

GLOUCESTER

Introduction

Great cities are often defined by their buildings. Think of Rome and you think of the Colosseum; Paris, the Notre Dame; and Brussels, the Atomium. When I think of Gloucester I think immediately of the cathedral. The oldest religious building in the city, it still dominates the cityscape, and today it's not just famous for its royal links but in more recent times is associated with such ventures as the Crucible Exhibition and the filming of *Harry Potter*. But Gloucester is so much more than this one iconic building. Over the centuries builders, architects and stonemasons have come together to create some of the most stunning buildings, many of them still standing today.

Gloucester has seen periods of enormous creativity and dedication to the craft. The medieval era was one such period, establishing Gloucester as an important place of worship and cementing its place in the ecclesiastical life of the country. A building frenzy in the Victorian era reflects Gloucester's part in the industrial wealth of the nation and, sadly, the sixties and seventies heralded the vagaries of planning decisions which still blight the city centre. The incorporation of Gloucester's Civic Trust in 1972 was in response to such widespread destruction of the city's architectural heritage. Even so, Gloucester has an abundance of Grade I and Grade II-listed buildings, reflecting more than 1,000 years of historically significant properties of varying architectural styles.

This book will take you on an architectural journey through the decades of building tradition, from medieval stone edifices to more modern, minimalist, rusted steel constructions.

The 50 Buildings

1. Gloucester Cathedral, College Green

The Cathedral Church of St Peter and the Holy and Indivisible Trinity is the oldest religious building in Gloucester. Osric, an Anglo-Saxon prince, founded a religious house on the site of the cathedral in AD 678–9. The foundation stone was laid in 1098 and it was subsequently consecrated in 1100. There have been many changes to the building over the years. The great east window was completed in the 1350s and the fan-vaulted cloisters were finished by 1412. Abbot Seabroke began the building of the tower in 1450 and later in the 1470s the Lady chapel was rebuilt by Abbot Hanley and completed by Abbot Farley between 1472 and 1498.

Although all periods of medieval church architecture are represented at Gloucester Cathedral, its two main building phases, Romanesque and Perpendicular, are of outstanding interest and importance. A great deal of this Romanesque church survives, including the entire crypt, much of the east end, the great nave piers, most of the north aisle and the Norman chapter house.

Both the Early English style and the Decorated style are also represented at the cathedral. Examples include the nave vaulting of 1242 in the Early English style, and the elaborate stone carving of Edward II's tomb in the Decorated style.

The basic plan of the cathedral is cruciform, with a tall central tower. Of major importance is the stained glass in the great east window, believed to be a memorial of the

A panoramic view of the cathedral, with the west window and the Perpendicular tower in view.

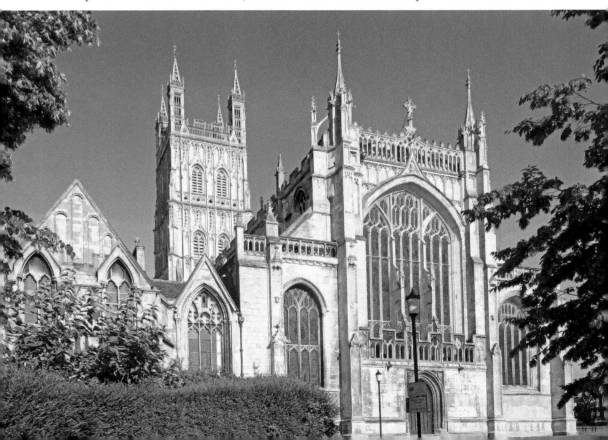

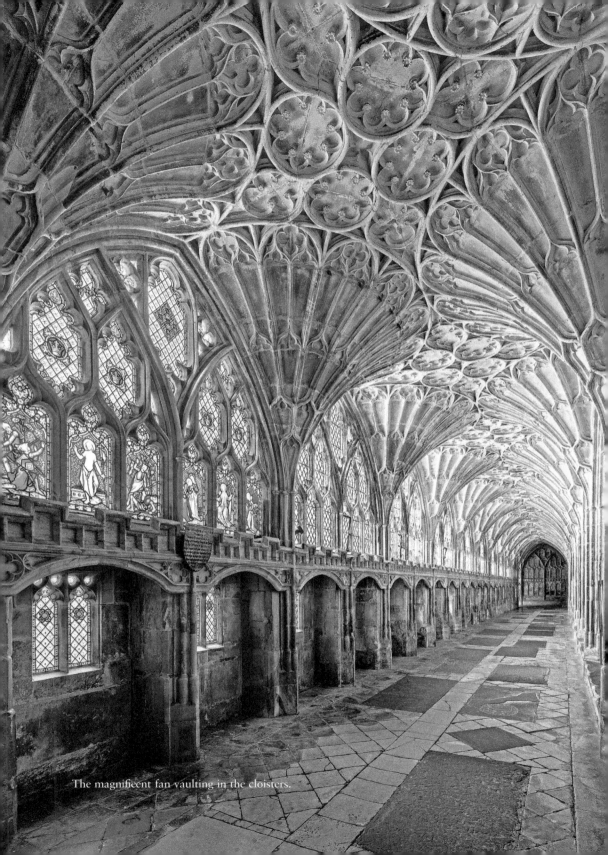

The magnificent fan vaulting in the cloisters.

The cloister gardens, showing the tower built in the Perpendicular style.

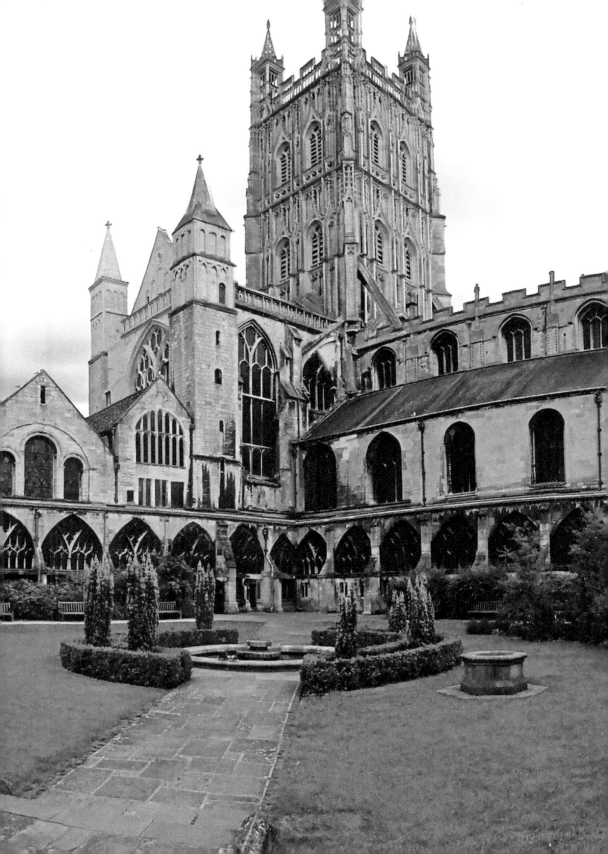

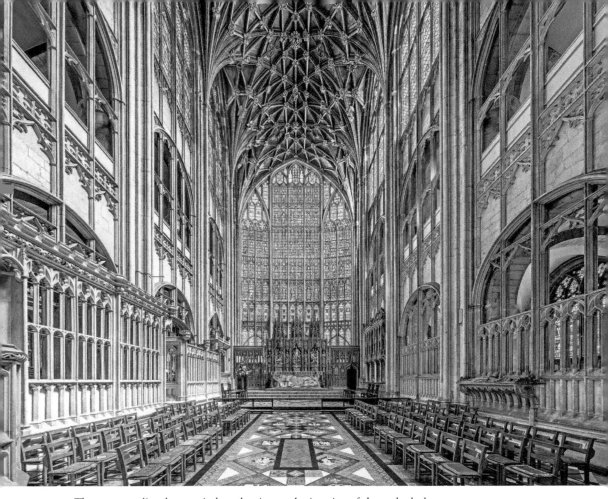

The great medieval east window dominates the interior of the cathedral.

Battle of Crecy but also incorporating some other panels of medieval glass. The great east window is situated in the choir behind the high altar and dominates the very heart of the cathedral. Installed in the early 1350s, the window is one of the greatest landmarks of English medieval glass.

The fan vaulting in the cloisters are one of the earliest and finest examples of English fan vaulting. The fan vault is an English innovation not seen in the churches of continental Europe. It developed in the fourteenth century as a shell form that was inserted into existing Norman or Romanesque structures as an alternative to the Gothic arch. The fan vaults of Gloucester cloister were constructed from centring bays based upon earlier Norman foundations.

2. St Oswald's Priory, Priory Road

The ruined remains of the north aisle of the nave is all that is left of this former Augustinian Priory of St Oswald, founded by Athelflaed, the daughter of Alfred the Great, in around AD 900. In AD 909, the bones of St Oswald were translated from Bardney Abbey in

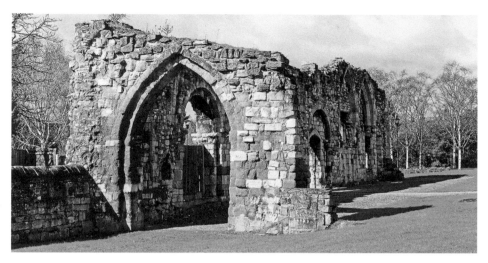

Above: The remains of St Oswald's Priory.

Below: A ninth century Anglo-Saxon cross found in a wall near St Oswald's Priory, now in Gloucester City Museum & Art Gallery. The left hand shows the original piece and the right hand shows the false colour version to pick out the figures and knots.

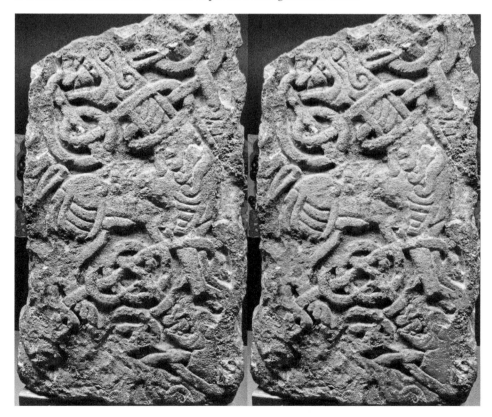

Lincolnshire, and the priory was renamed St Oswald's in his honour. The relics were placed in a crypt at the east end of the church where it is also thought Athelflaed and her husband were buried. For the next century St Oswald's was noted for its wealth and for its miracles. It became known as the Golden Minster. Following the dissolution, the priory was largely demolished, except for the aisle, which was converted for use as the parish church of St Catherine.

3. Llanthony Secunda Priory, Llanthony Road

This former Augustinian priory was founded by Miles de Gloucester, 1st Earl of Hereford, in 1136. Seven listed buildings still exist on the site, including the remains of the range between the Outer and Inner Courts, the ruins of a fifteenth-century tithe barn and the sixteenth-century West Gate, which can be seen from Llanthony Road. Much of the site was destroyed when the canal was constructed, which also destroyed the graves of its founder and his family.

A sketch by Phil Moss, showing the extensive layout of Llanthony Priory, its outbuildings, the range and the gatehouse.

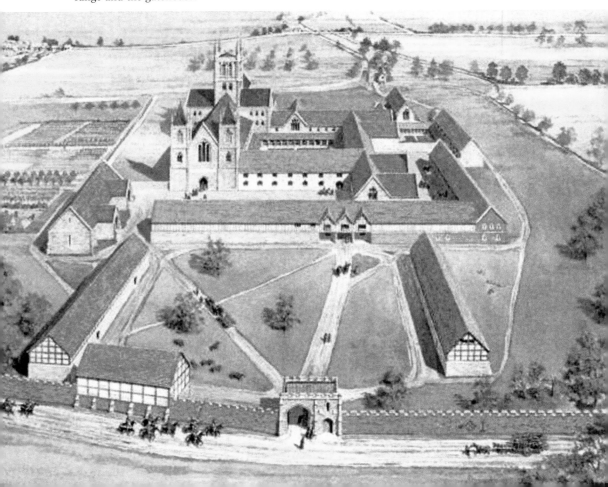

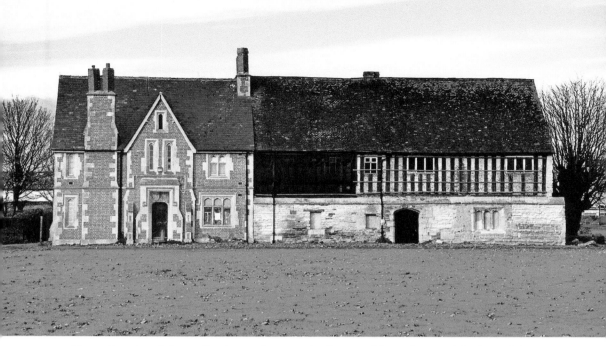

Above: Remains of the medieval range between the Outer and Inner Courts of the Augustinian Priory of Llanthony Secunda with adjoined Victorian farmhouse.

Below: The remains of the tithe barn.

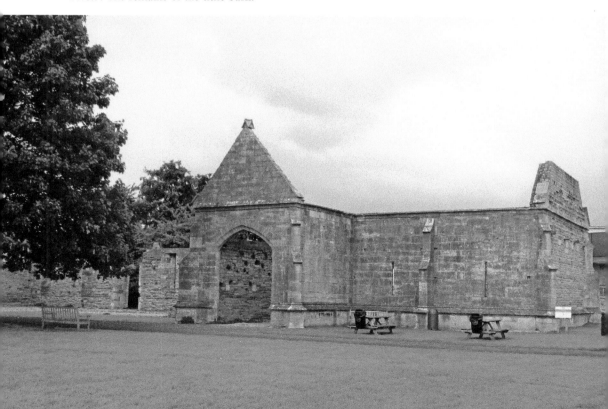

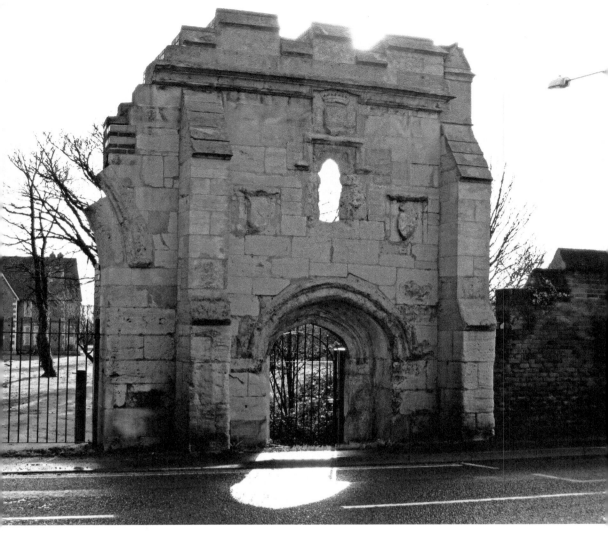

The remains of the West Gate, which dates from around 1550. This outer gatehouse served as a pedestrian access with gatekeeper's chamber above. The single light, arched window would have been originally closed with a wooden shutter. The upper stone shield bore the arms of France and England quarterly for Henry VII, who often visited the priory. The shield on the left bore the arms of the de Bohun family, who were the wealthy benefactors of the priory and on the right the shield bears a chevron with three Cornish choughs representing the arms of Henry Dene, the prior of Llanthony.

4. Church of St Nicholas, Upper Westgate Street

This church, first recorded in 1180, stood near the old west gates of the city. It was known as St Nicholas of the Bridge of Gloucester and belonged to the crown, which suggests that it was founded by a monarch. It probably sprung up at the same time as Westgate Bridge was erected, around 1119, to serve the growing population of Gloucester. In 1229 the church was given to St Bartholomew's Hospital, and both maintained a close relationship

throughout the medieval period. It was later granted to the City Corporation – essentially the city government. It was largely rebuilt in the thirteenth century.

The tower is a real local landmark with its distinctive spire. The spire was hit by cannon fire in the Civil War siege of Gloucester in 1643, and it was lowered and topped with a lead cap in 1783 to produce the current and oddly truncated look.

The interior is a reminder of Gloucester's prosperous past, with glorious vaulting in the tower and a plethora of historic funerary monuments to prominent city merchants. During the medieval period several chantries were established within the church, including one to Thomas of Canterbury and another to St Mary. In addition, there were three side altars, indicating that this was a very busy and prosperous church, perfectly in tune with Gloucester's prosperity during the medieval period from the wool and shipping trades. There are squints on both sides of the chancel arch, allowing the congregation to view the high altar from the sides of the nave. These had to be inserted in the sixteenth century when the church became extremely popular and was crowded during services.

One unusual feature is that the church leans at a very noticeable angle. Perhaps the best place to appreciate the awkward angle at which the building finds itself is simply to stand at one end of the nave and look straight ahead.

As you enter through the north door, the original Norman tympanum is still there, above the porch door of the church. A tympanum is the semi-circular or triangular decorative wall surface over an entrance, bounded by a lintel and arch. It often contains sculpture or other imagery or ornaments. In this case it depicts Agnus Dei – the Lamb of God.

An ancient treasure used to adorn the south door of the church. Thought to be a bronze sanctuary knocker at one time, because it lacks a beating plate scholars now think it is more likely to be an elaborate form of closing ring. The bronze was cast as a single piece using the *cire perdue* method, considered to be a considerable technical achievement for the time.

The principal motif, cast in high relief, is that of a grotesque with a human head, flowing locks, long pointed ears, short stumpy legs and hairy forelegs each ending in a paw with four digits with sharp claws. The ring passes through the attenuated neck of the grotesque. The secondary motif, back to back with the grotesque, is a human face with an open mouth and protruding tongue. This figure is wearing a close fitting 'balaclava-like' headdress, which covers the hair and ears and reaches to the point of the chin. At the top of the escutcheon is a group of stylised foliage raised on a stem; a similar group appears at the bottom of the escutcheon but this has been much battered and broken by the action of the ring. The closing ring is on display in the City Museum.

Inside the church is the well-preserved and most impressive tomb of John Walton and his wife Alice. The tomb itself was carved by Samuel Baldwyn. John was a Goldsmith, a former City Alderman and Sheriff of Gloucester. He wears the red robes of office while his wife Alice has a broad-brimmed hat worn over a coif, with neck ruffle, showing a northern European influence which was stylish at the time. Kneeling by them, at the base of the tomb, are two figures, thought to be their son and daughter.

The Church of St Nicholas is no longer in regular use and is cared for by the Churches Conservation Trust.

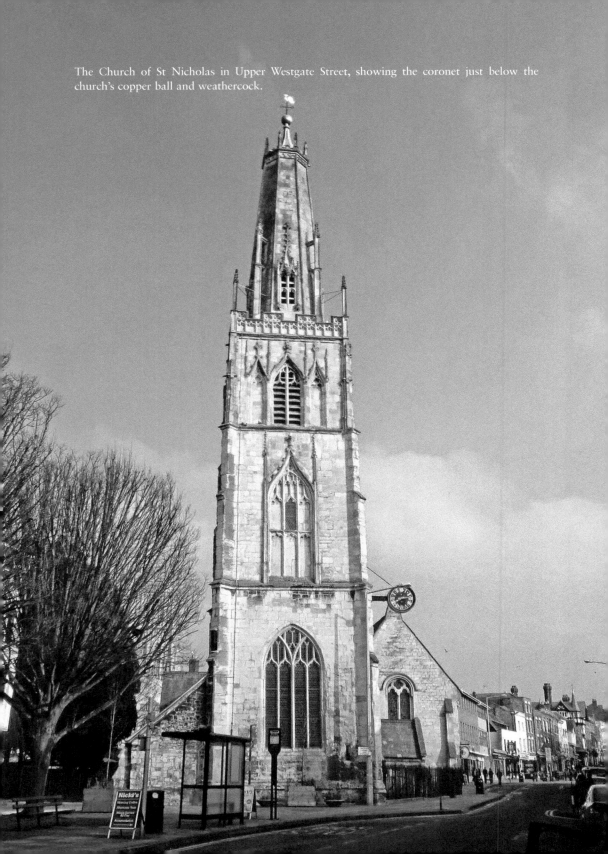

The Church of St Nicholas in Upper Westgate Street, showing the coronet just below the church's copper ball and weathercock.

Right: The earliest known picture of the Church of St Nicholas and tower is sketched in the Rental Roll of 1455. The coronet is clearly visible, along with the rest of the spire.

Below: The Norman tympanum above the porch door of the Church of St Nicholas, depicting Agnus Dei.

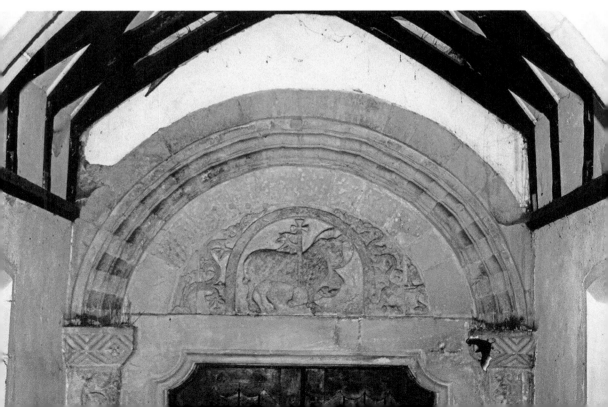

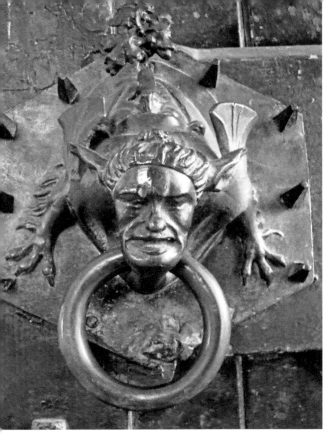

Left: The early fourteenth-century 'sanctuary knocker', which once adorned the south door, remarkably preserved due to its location within the porch.

Below: The well-preserved effigy on top of the tomb of John and Alice Walton in the Church of St Nicholas.

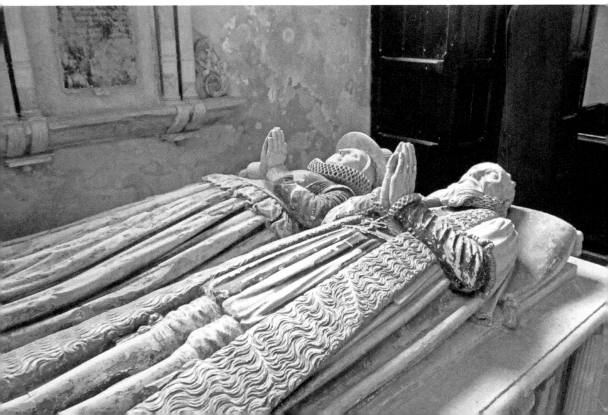

5. Church of St Mary de Lode, St Mary's Square

The tower and chancel of this church are medieval, and were built in 1190. The chancel was extended by one bay and vaulted in the mid-thirteenth century, while the nave was rebuilt in around 1825 or 1826 by James Cooke, a local mason, in the plain Early Gothic style. There are also two wall tablets dated 1819 that are attributed to him. Further restorations have taken place since.

In 1826, when workmen were enlarging St Mary de Lode's churchyard, they uncovered wood ash and the remains of a large stake on a mound close to St Mary's Gate. This is believed to have been the site of Bishop Hooper's burning. The stake is kept at the Gloucester Life Museum.

Inside the church is an eighteenth-century organ, which was taken from the Church of St Nicholas Westgate Street in 1972. There is also an octagonal pulpit of richly carved wooden panels from the fifteenth century.

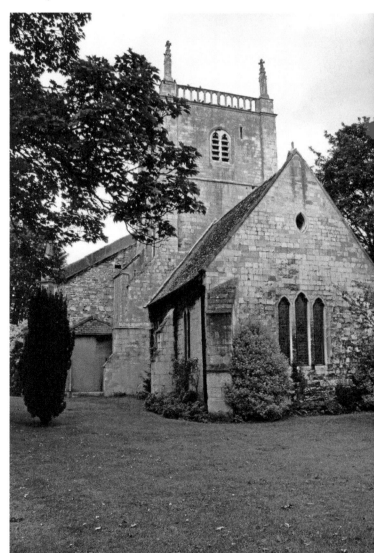

The rear of the Church of St Mary de Lode, showing the medieval tower and chancel.

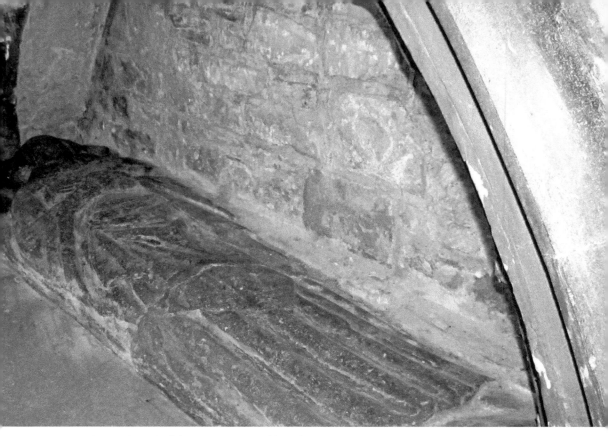

In the north wall of the chancel is an effigy of a priest in Eucharistic vestments, reset within a mutilated fourteenth-century arched recess. It is believed to depict William de Chamberlayne, who died in 1304.

6. Tanners' Hall, Gouda Way

This house, built in the thirteenth century on the east side of Hare Lane, is the only medieval domestic stone house in Gloucester of which any detail is known. It is also the oldest secular building in Gloucester. From at least 1565, the building was being used by the Company of Tanners, probably one of the oldest craft organisations in the city. During the 1980s the site was excavated and five troughs and eight vats were discovered below ground level. A search of documents in the records turned up an inventory from 1669, which revealed the extent of the trade carried out on these premises. Sadly, there is very little that remains of the building today.

The following schedule was attached to a lease dated 1669:

A Schedule or Inventory of all such goods and Instruments of and belonging to the Trade of Tanning that doth belong to the Master Wardens and Company of Tanners within the City of Gloucester Situate and being in and about the messuage or Tenement called their Common Hall taken the 6th July 1669.
'Imprimis In the Court next the house Fower Trowes
In the porch One Trowes

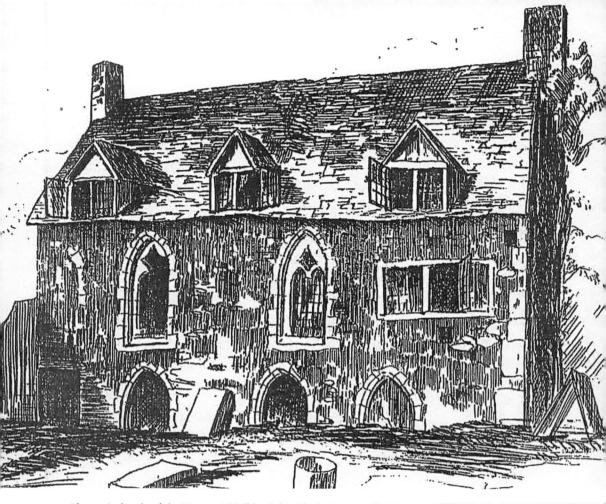

Above: A sketch of the Tanners' Hall by John Clarke in 1850, showing the original building.

Right: The tanning pits discovered when the building was excavated in the 1980s.

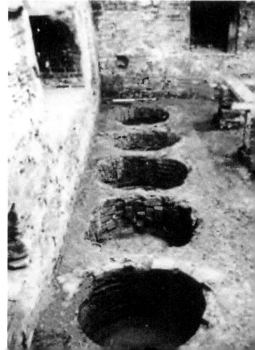

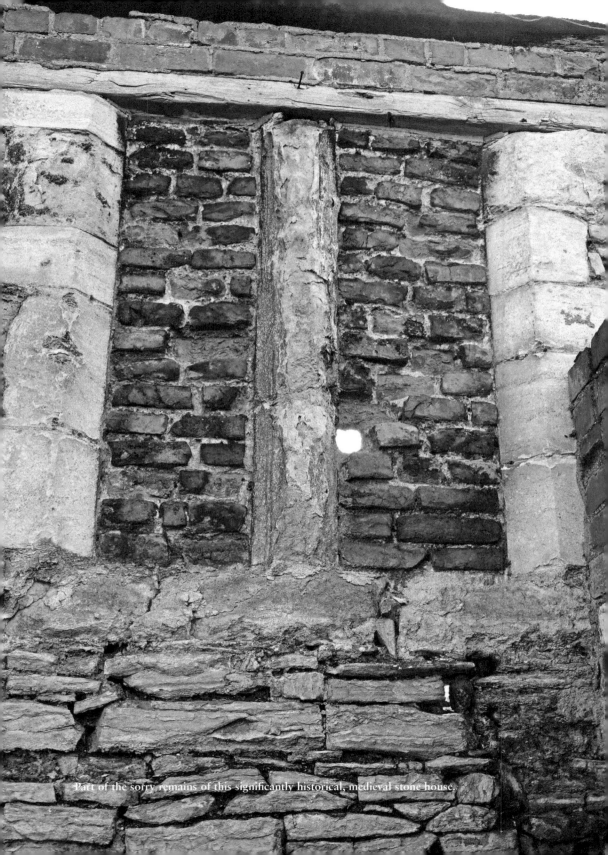

Part of the sorry remains of this significantly historical, medieval stone house.

In the Tannhouse five trows and eight Vats

Without doors Fower Vats One Share to work in at the brooke Fower Limes and three masterings One pump one mill and millston one oast Stagers on the North side East and West end the Drying house and millhouse Stagers on the South Side and West end the Dwelling house and Bace house to ye Streete One little bricke house for a pantry next e street One house of office.'

Gloucester's oldest standing secular building was once a busy hub of commercial city life, but fell into disrepair and almost went 'missing' until it was rediscovered when a new road was driven through.

7. Greyfriars Priory, Greyfriars Walk

Greyfriars Priory was founded in 1231 on land granted to the Church by Lord Berkeley. It was one of three Gloucester monasteries supported by Henry III.

The Grey Friars, or Franciscans, were followers of St Francis of Assisi and founded many religious houses across Europe. They earned their name from the grey habits that were worn as a symbol of their vow of poverty.

By 1285 the priory was home to forty begging friars. This is known because there still exist records showing that they were locked into a series of disputes with the monks of St Peter's Abbey (Gloucester Cathedral). The dispute was long standing, culminating in a quarrel over their shared water supply in the fourteenth century, which had to be settled by Edward the Black Prince, son of Edward III. The Franciscans won.

In around 1518 a member of a prominent local family, Maurice Berkeley (one of the Berkeleys of Berkeley Castle), paid for the friary to be rebuilt in the Perpendicular Gothic style. The design conformed to the usual monastic plan, with a large church and then the chapter house, refectory, dormitory and other buildings ranged round a central cloister. Most of these structures have been demolished, but the remains of the church can still be seen; its spacious proportions demonstrate that it was designed to hold large congregations in keeping with the Franciscans' mission. The nave and the north aisle still survive and reveal the high quality of the original building.

As in many other friaries, the aisle was almost as wide as the nave itself and would originally have had seven bays. In each bay, large four-light arched windows can be seen, and at the east end of the north aisle there is evidence of a six-light window. Some of these windows still have portions of Perpendicular tracery. At the south side of the nave there is a trace of the former north walk of the cloister. Reset in the outer face of the south wall of the nave are two stone shields carved with the arms of Chandos and Clifford of Frampton that may originally have decorated a funerary monument. There was also a large cemetery to the north of the church where many of the benefactors of the friary lie buried.

But the greatness of this fine building was not to last long. In 1539 the friary was surrendered to Henry VIII during the Dissolution of the Monasteries. Over the following years, the buildings were put to a number of different uses and in 1643 they were severely damaged by Royalist forces during the Siege of Gloucester.

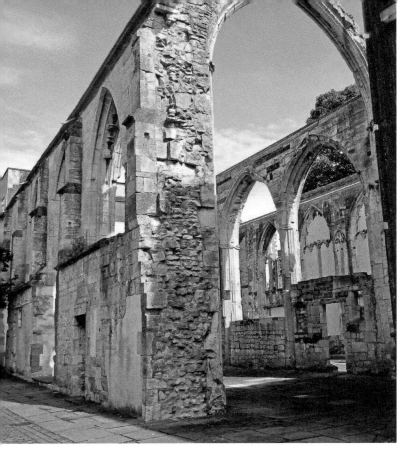

Left: The remains of Greyfriars Priory, showing the remains of the arched windows.

Below: Greyfriars House, built into the ruins of the medieval priory.

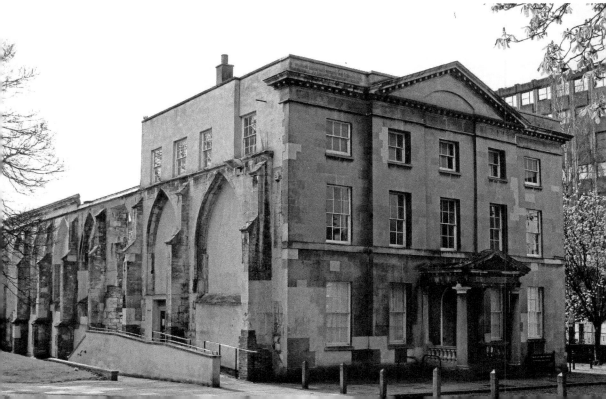

By 1721, only the nave and its north aisle had survived. In 1810 a large house was built in the Classical style into the west end of the medieval remains for Philo Maddy, a local currier. Greyfriars House is now a public library.

8. Blackfriars Priory, Blackfriars

The Dominicans, or Blackfriars, first came to Gloucester in 1239 at the instigation of Sir Stephen de Hermshall. The building of the house began almost immediately, largely with materials and funds donated by Henry III. When it was completed in around 1270, it became home to some forty friars. For three centuries, the friars were a familiar part of the church establishment, enjoying a revival of popularity at the very end of the Middle Ages. Unfortunately for them, the property they owned was considerable and they were suppressed, along with the larger monasteries, in 1539. By this time the number of friars living in Gloucester had fallen to just six and a prior.

Following the dissolution, a local alderman and cloth manufacturer called Thomas Bell bought the former priory and converted it into a mansion and the other buildings into a weaving factory. In the nineteenth century the west range became a row of terraced houses and the scriptorium or library range was used for bottling. Extensive conservation work has been carried out on the property since 1960, when all post-medieval floors and partitions were removed to expose the proportions of the church and the surviving medieval features.

The building is noted for the almost complete nature of its survival, the rare architectural features and its history of adaptation and use. In particular, the priory has a unique and surviving scriptorium or library, complete with rows of twenty-nine identical study carrels which would have been used by the monks. Some medieval graffiti was also

A 1721 sketch, by the antiquarian Stukeley, of Blackfriars Priory.

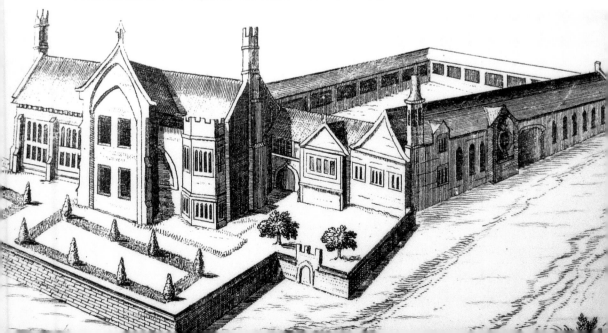

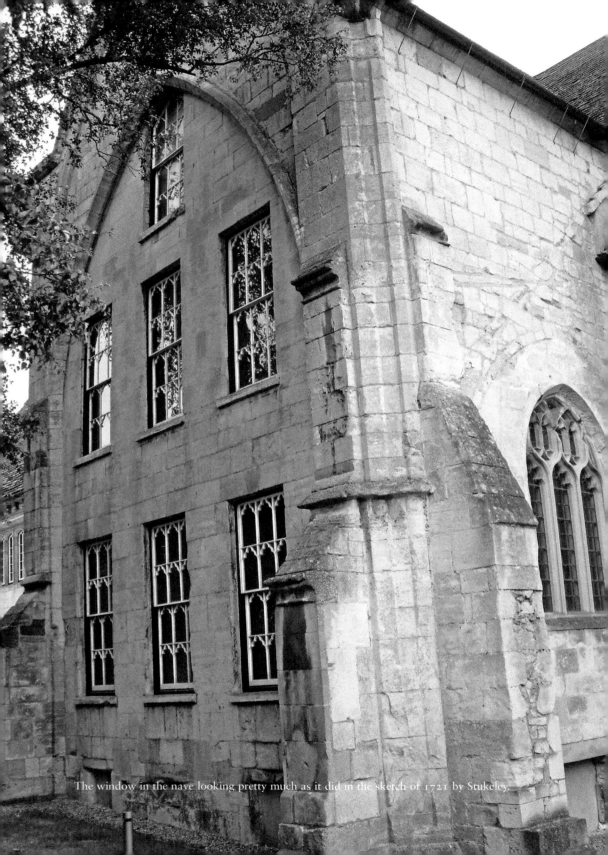

The window in the nave looking pretty much as it did in the sketch of 1721 by Stukeley.

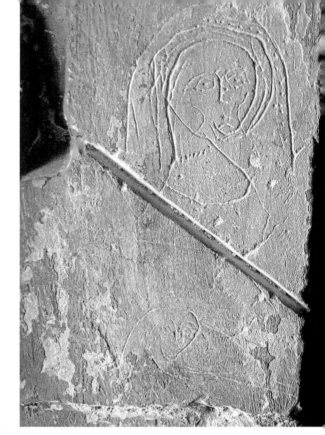

Medieval graffiti in the scriptorium
of Blackfriars Priory, thought to be a
representation of the Madonna and Child.

The pulpitum, a rectangular, stone lectern
from which the monks of the priory would
preach. The lectern was carved with the
ancient monogram of Jesus, IHS, meaning,
'in the name of God'.

discovered, believed to be the Madonna and Child and most likely to have been carved by a pious monk.

On the outside of the south range is the remains of a thirteenth-century lavabo situated in an arcaded recess, with barely legible writing above. The scriptorium and nave have the most magnificent original scissor-brace roof, which is documented as a gift from the royal forests during Henry III's reign. The refectory was situated at the south end of the west range where there is an impressive triplet of lancet windows in the south gable-end wall. The priory also has a dormitory in the range opposite, above the Chapter House where the affairs of the priory's community were decided. In later years, part of this east range became a separate lodging for the prior. There is some surviving wall decoration within the prior's lodging.

9. Chapel of St Mary Magdalene, London Road

The chancel of the chapel is all that remains of this former leper hospital of St Mary Magdalene. The leper chapels served the medieval hospitals, or almshouses, and were dedicated to their respective saints, in this case St Mary Magdalene. Also known as the Hospital of Dudstone, it was founded in the early 1100s, probably by Walter of Gloucester, initially for thirteen lepers. In the early 1150s the hospital received support from Roger, Earl of Hereford. Because of his family's close connection with Llanthony Secunda Priory, the hospital came under the control of that priory. A manuscript in Corpus Christi College in Oxford relates that 'the brethren received to the value of 12*l* 6*s* 8*d* for providing loaves called the loaves of Dudestan and other necessaries from the priory of Lanthony to the monks of which the cure of this house the usual title for obtaining of holy orders'.

The original elaborately decorated Romanesque south doorway was reconstructed facing east in the chancel arch, and the north doorway was set against the south wall of the chancel.

The most interesting historic feature is a life-sized thirteenth-century recumbent effigy of a woman. The effigy was brought here from a demolished chapel dedicated to St Kyneburgh, which stood near the south gate to Gloucester at Kimbrose Way. Kyneburgh was a Saxon princess, the daughter of King Penda of Mercia, who died around AD 680. Tradition says that the effigy represents Kyneburgh herself. However, it has been suggested that stylistically it is more likely to have been one of the daughters of Humphrey de Bohun, possibly Margaret or Isabella, who is known to have died young in the thirteenth century. The link with the de Bohuns, who were the hereditary Constables of England, arose because St Kyneburgh's chapel had also formed part of the original endowment of Llanthony Secunda Priory. This appears to be supported because an effigy with a similar description is mentioned by Thomas Fosbroke in his *Original History of the City of Gloucester*, written in 1819 when St Kyneburgh's chapel was still standing.

Outside the chapel, there are some excellent examples of medieval graffiti by the entrance door. Their origins have never been fully explained, but it has been suggested they may have been linked with pilgrimages. They include crosses and floral motifs.

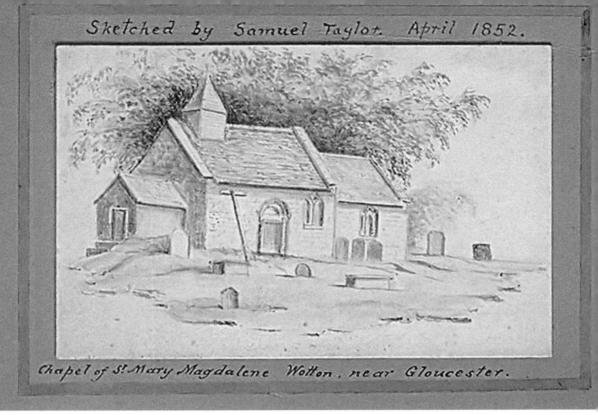

Above: A sketch by Samuel Taylor in 1852, showing the remains of the leper chapel.

Below: The remains of the twelfth-century Chapel of St Mary Magdalene as it looks today.

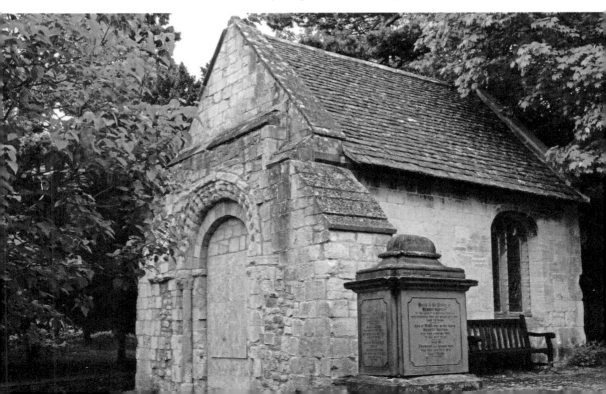

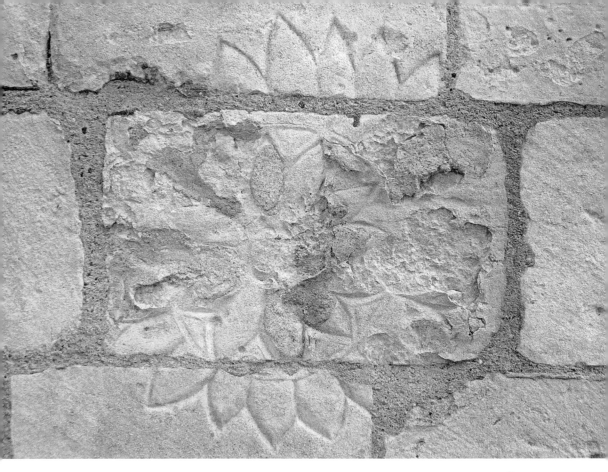

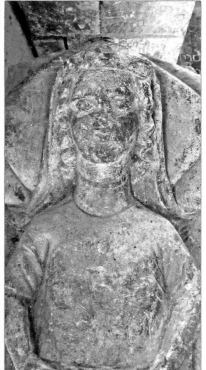

Above: Medieval graffiti, showing a Star of Epiphany on the external wall of the chapel.

Left: The recumbent stone effigy of a lady. Local legend asserts that this is the effigy of St Kyneburgh, a Saxon princess.

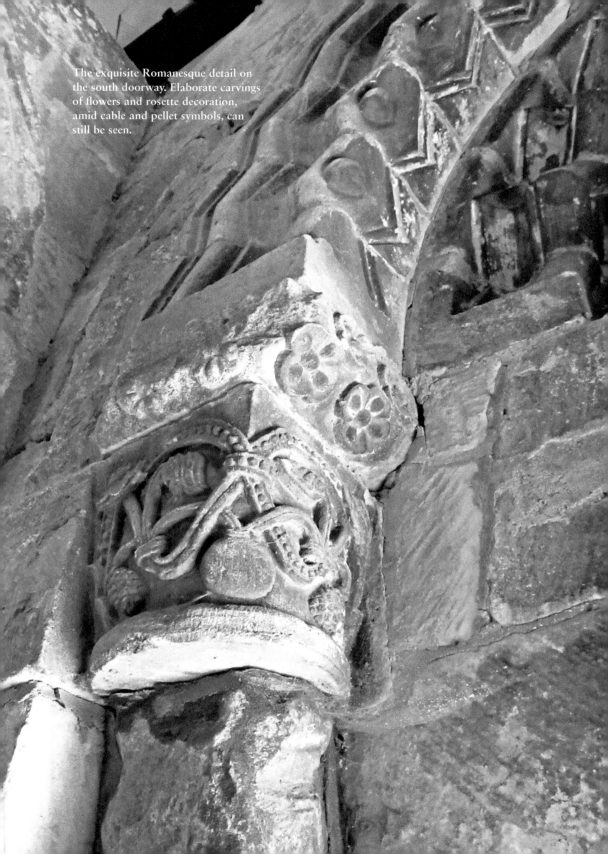

The exquisite Romanesque detail on the south doorway. Elaborate carvings of flowers and rosette decoration, amid cable and pellet symbols, can still be seen.

10. No. 26 Westgate Street, Maverdine Lane

Hidden behind a Georgian facade and extending for some distance along a long and narrow alley lies one of the most substantial timber-framed merchants' houses to have survived in any English town. The building is notable for the quality of its surviving detail, which includes rare and original patterned leaded glass that can be seen if you look upwards from within the alley.

The formerly impressive multi-jettied front was recorded by J. C. Buckler in the early nineteenth century before it was hidden from view. At the rear of the elevation, facing Maverdine Lane, there is a significant and rare survival of seventeenth-century limewashed and comb-decorated render along with elaborate, late sixteenth or early seventeenth-century architectural features and detail, including the ground floor of rubble wall believed to contain reused Roman masonry.

Once owned by local mercer, Alderman John Browne, the ground-floor front room was oak-panelled, with the Browne arms above the overmantel. In 1772 it was owned by William Bishop, a local grocer and became known as the Hall of the Grocer's Guild. In the early nineteenth century it was used as the Judge's Lodgings and then from 1886 to 2015 it was owned by Winfields, the Seed Merchants. It has recently been sold to a private buyer.

A sketch of No. 26 Westgate Street by F. W. Waller in 1877, showing the extent of the hidden building in Maverdine Lane.

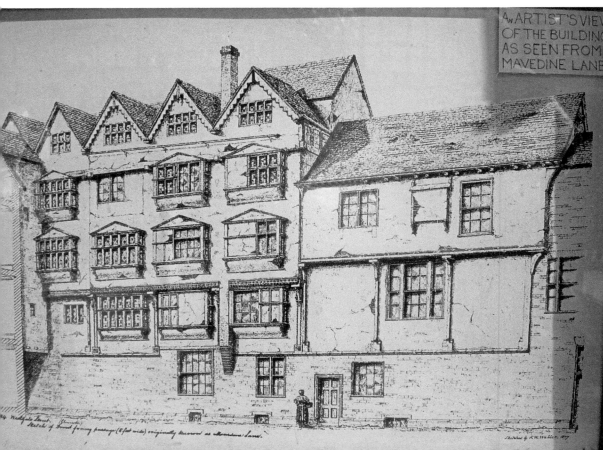

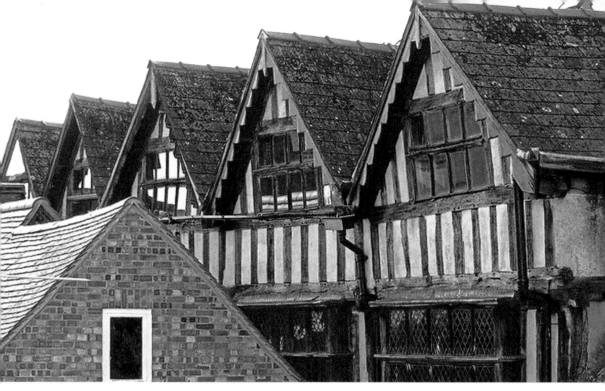

Above: The view of the top two floors of this five-storey building, showing in more detail the oriel windows in each bay. Each oriel is capped with a shallow gable, like a pediment. In each of the dormer gables there is a four-light casement with timber mullions and an upper transom. The three gable dormers to the right have stepped barge boards.

Below: The original, early seventeenth-century wrought-iron casements with original elaborately patterned leadlight glazing and original iron catches.

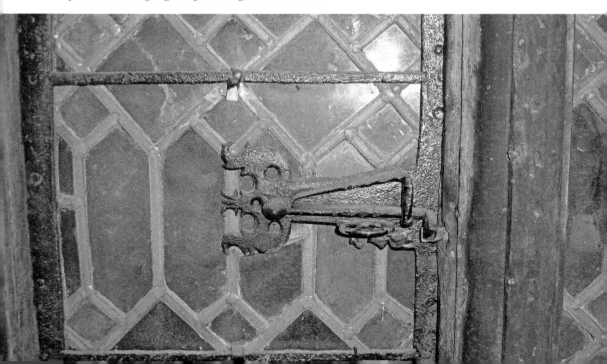

11. Church of St John the Baptist, Northgate

It is thought that a church on this site existed as early as AD 931, said to be founded by King Athelstan. In the eleventh century it was rebuilt and dedicated to St John the Baptist. The bulk of the present building, however, dates from 1732, when it was designed and built by Edward and Thomas Woodward of Chipping Campden in the Provincial Classical style. A beautifully, symmetric frontage consisting of three parts: the central part set between classic Roman Doric pilasters or columns with a large Venetian window of stained glass, framed by an Ionic pilaster. Doors either side of the central projection each have a circular window above, adding to the symmetry. Sitting above this is the West Tower, which consists of three stages: the lower stage features a twentieth-century crenelated parapet with moulded capping, a two-light window on each face in the middle stage and similar belfry windows in the upper stage, all with Perpendicular tracery. Inside, the nave has five bays with colonnades of four Roman Doric columns.

Samuel Rudder noted that before the Dissolution 'the church belonged to the abbey of St Peter (Gloucester Cathedral) to which it had been confirmed by the kings Henry I and Stephen and it was appropriated by Abbot Hameline (of Llanthony Priory) to the precentor for maintaining the feast of St Oswald'. He also claims that after the Battle of Bosworth in 1485, Lord Stafford and Francis, Viscount Lovell fled to this church for sanctuary.

A church of some importance in the community, there are several persons of note buried here, including Sir Thomas Rich in 1607, the father of the pious founder of the Bluecoat Hospital. He was said to have given 'eight pieces of gilt plate and a considerable amount of crimson velvet and linen for the service of the church'.

Monuments inside the church date from medieval times and include many floor slabs and, on the north wall of the nave, two brasses of figures from a memorial to John Semys, who died in 1540, and his two wives. Samuel Rudder notes that 'upon a large grave stone in grey marble, which was in the chancel before the old church was demolished but now altered or taken away was a plate of brass on which the effigy of a man at length between two wives and several children was engraven and the following inscription in old black character':

> Here under buried John Semys lyeth
> Which had two wives the tuft Elizabeth
> And by her vi ſoonnes and daughters five
> Then aftur by Agnes his ſecund wive
> Eight ſoonnes ſeven daughters goddes plente
> The full numbre in all of ſix and twentie
> He parted to God in the moneth of Auguſt
> The thouſand five hundred and fortie yere juſt 24 Aug.

On the north wall of the chancel is a baroque, gilded monument effigy to Thomas Price, Master of the Horse to Charles I and twice Mayor of Gloucester, who died in 1678. There is also an upright, upper-half effigy on the south wall, with a small recumbent effigy of his daughter, Dorothy Price, who died in 1693, both by Reeve of Gloucester. Some years later, a communion table and rails were given to the church in 1734 by Bridget Price. These can still be seen here.

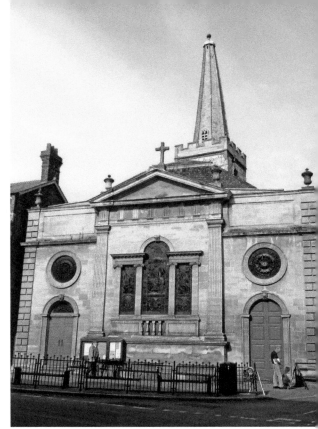

The exterior of the church of St John the Baptist showing the octagonal, truncated spire. There are two-light lucarnes, which are the small, gabled openings in the spire. At the apex is the lead capping with a ball finial. In the centre of the building is a large Venetian window framed by Ionic columns.

The top of St John's spire, which was removed in 1910 and placed in the cemetery, is now in St Lucy's Garden where it remains.

The wooden pulpit is all that remains of the original 'three-decker' from which both George Whitefield and John Wesley are known to have preached. A stained-glass memorial to Robert Raikes and Revd Thomas Stock on the centenary of the foundation of the Sunday School movement in Gloucester was created in the east window in 1880 by the Camm Brothers of Smethwick.

The top portion of the spire was removed from the church in 1910 and placed in St Lucy's Garden, behind St John's Church Hall in Hare Lane.

In the early 1970s, the church decided to sell off some of the land, following which the Northgate Chapel was subsequently demolished and a supermarket built in its place. The current St John's Church Hall has been built on top of the old St John's burial ground. When the burial ground was cleared, the remains were reinterred in the old Gloucester Cemetery on Tredworth Road.

12. The New Inn, Northgate Street

This building began life as a large hostelry, built for the former Benedictine Abbey of St Peter by John Twyning, a monk of St Peter's Abbey, on the site of an earlier inn, hence its name. The building is unique in that it is the most complete surviving example of a medieval courtyard inn with galleries. It's thought the inn was built to provide lodgings for the throngs of pilgrims visiting the tomb of Edward II in St Peter's Abbey.

An expansive, rectangular building with a frontage facing Northgate Street, it originally featured seven framed bays with continuous jetties to the upper floors. It is a classic medieval design of massive timber oak frames with rendered panels, including some original lathe and plaster noggin. Accessed through the original carriageway, the inn opens up to a courtyard surrounded by open galleries, providing access to the upper floors where the pilgrims slept together in large, communal chambers. New Inn Lane, at the side of the building, gives the visitor an impressive view of the jettied, upper-floor levels. Of particular architectural note is the original, richly decorated dragon post on the ground floor at the north-west corner, carved with a niche containing the mutilated figure of an angel under a pinnacled canopy, and with panels of Perpendicular tracery.

Within the courtyard is a continuous gallery at first-floor level on all sides, with evidence for wooden mullioned windows with traceried heads. Access is gained to this gallery by an external staircase. From this vantage point, you are able to see two enormous timber beams framing the carriageway entrance, most likely brought from oak trees growing in the Forest of Dean.

Throughout the building there are original timber-framed walls, the best examples of these can be seen in what is now the restaurant. On the first floor, there is an example of a fine Tudor ceiling, which was a later addition to the building.

At the dissolution of the abbey, the inn passed to the Dean and Chapter of Gloucester Cathedral and was leased to various inn holders until it was sold in 1858.

There are rumours of a tunnel running from the inn to the abbey but this has never been proved. It was reputed that the New Inn was one of only three places in the country where Lady Jane Grey's succession to the throne was publicly proclaimed in 1553 and it is speculated that Shakespeare may have performed at the inn in the sixteenth century. By the eighteenth century, the New Inn was an important venue on the Gloucester to London stagecoach route. It was bought by Bernie Inns in 1954, when it had thirteen separate bars.

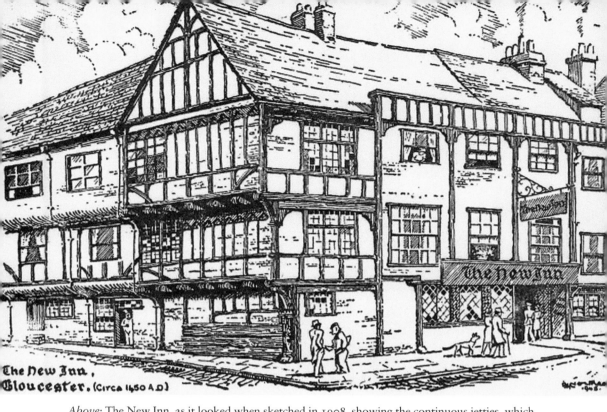

Above: The New Inn, as it looked when sketched in 1908, showing the continuous jetties, which have since been covered up by the addition of boards imitating timber storey posts.

Below: The New Inn as it looks today, remarkably unchanged, except for the addition of modern shop frontages.

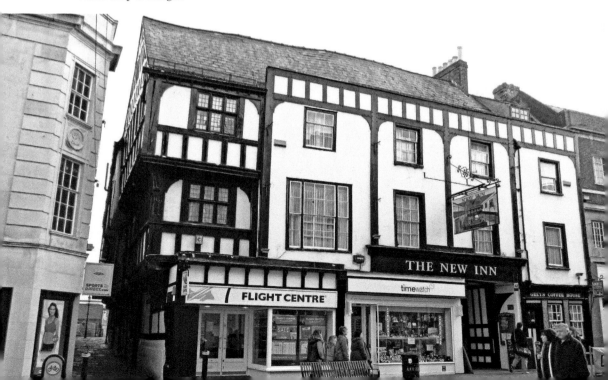

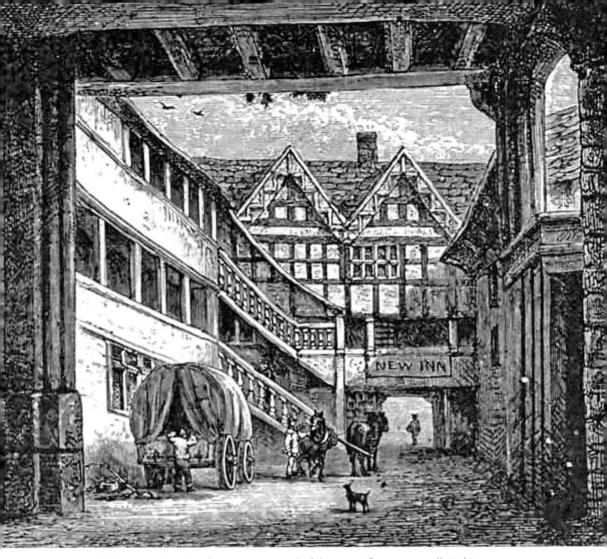

An old drawing, showing the inner courtyard of this magnificent open-galleried inn.

13. The Fleece Hotel, Westgate Street

The Fleece Inn is believed to have been developed as an inn around 1497 by St Peter's Abbey, again to accommodate the growing number of pilgrims flocking to the tomb of Edward II. It was built on the site of a merchant's house in a property that originally extended westward to Bull Lane. It was recorded in the Rental Roll of 1455 as 'a great tenement that had belonged to Benedict the Cordwainer in the reign of Henry III'. The Norman undercroft, which still survives, is an exceptionally fine and early surviving example of its type and bears comparison with examples elsewhere in the country and in northern Europe, and is the surviving part of this earlier building. A brick-walled passage from the north-west corner of the undercroft leads to a brick-vaulted cellar below No. 19a Westgate Street.

Above: The Fleece Hotel, showing the nineteenth-century timber-framed facade, which is thought to hide older eighteenth-century brickwork.

Below: This old postcard shows the undercroft of the Fleece Hotel when it was a local bar known as the Monk's Retreat.

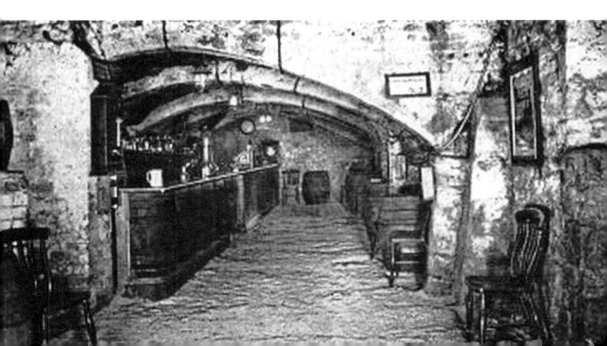

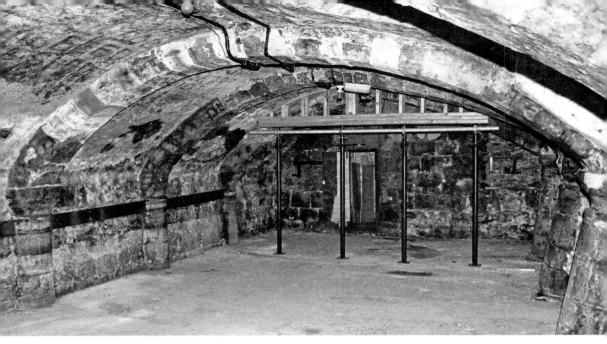

The Norman undercroft beneath the Fleece Hotel, showing the larger part below the southern end of the range. It has a segmental barrel vault in five bays, shown here, defined by transverse chamfered arches, which spring from semi-circular wall piers with concave capitals and square abaci.

The site is extensive, being a long, fifteenth-century range at right angles to Westgate Street, with a large courtyard accessed through a carriageway below the west end of No. 17 Westgate Street. Above this entrance is the date 'Circa 1497'.

In 1673 the inn was recorded as the Golden Fleece Inn. Between 1772 and 1778 considerable alterations and repairs were recorded. The building now has a mixture of building styles and includes some exposed timber framing within the building and a fireplace in the rear of the east wall of the bar has moulded stone jambs from around 1500.

14. Ye Olde Restaurant and Fish Shoppe, No. 8 Hare Lane

A former timber-framed merchant's house, it has jettied upper floors on the frontage and exposed timber framing on the upper floors. On the ground floor, there are twentieth-century windows in timber frames and on both the first and the second floors two early nineteenth-century three-light casements with glazing bars in the openings with their original sill rails.

On the first floor restaurant there is an unusual stone carving of a person with angel wings.

Opposite above: The chip shop, showing the two bays, jettied at first and second-floor levels.

Opposite below: The peculiar architectural stone mouldings on the upper floor of the restaurant.

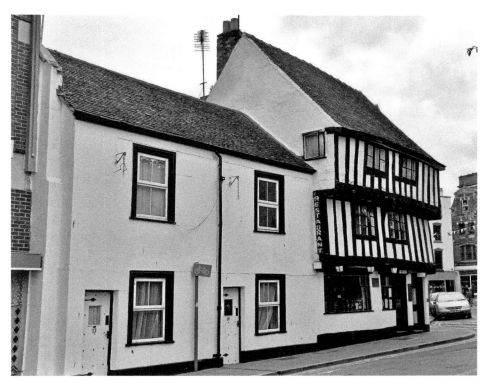

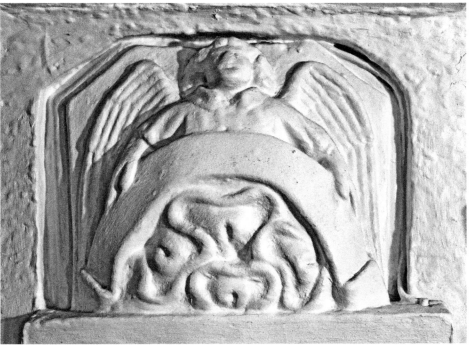

15. Dick Whittington Tavern, Upper Westgate Street

Hidden behind a Georgian facade, this former merchant's house is now a public house. The building is associated with and was possibly built for the family of Richard Whittington of Pauntley, who later became Mayor of London. It is a very important late medieval town house, with eighteenth-century alterations of high architectural quality. The building is best seen from the side lane fronting onto the church of St Nicholas where the long timber-framed wing at the rear can be seen.

It is claimed that Elizabeth I stayed here during a visit to the city in 1574 and during the seventeenth century it was leased by John Taylor, who got into trouble for inviting the mayor and aldermen to the premises while he had servants dying of the plague in the house. One of these is still said to haunt the Black Cat Bar downstairs.

On the first floor, off the stair landing, a recess with the face of a wall to the right has been opened and framed to expose part of a decayed fifteenth or possibly sixteenth-century wall painting, probably a townscape on plaster. Off the corridor, on the east side of the wing, is a room with a mid-seventeenth century panelled dado, of which several sections have been removed to expose a late sixteenth-century painted dado of fruit, flowers and foliage on plaster, possibly the lower portion of a full-height scheme

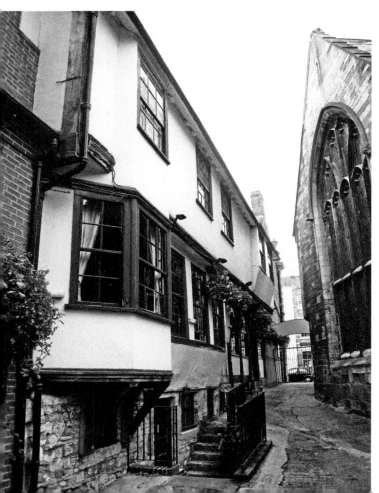

View from the side of the building, revealing the long timber-framed wing at the rear adjacent to St Nicholas's Church, and showing the continuous first-floor jetty of this late medieval town house.

The remains of what is thought to have been a full-height painted wall decoration. This late sixteenth-century painted dado of fruit, flowers and foliage on plaster is a rare and significant survival.

16. Gloucester Old People's Centre, the Old Raven Tavern, Hare Lane

Another fine merchant's house in Hare Lane dating from around 1520, with continuous jetty at the front and two gabled dormers with quatrefoil detail, which were added during the sixteenth century.

The house has been popularly associated with the Hoare family, who have been associated with Gloucester since 1465, namely Thomas Hoare, Burgess of Gloucester, and Richard Hoare of the parish of St John the Baptist, who was Sheriff of Gloucester in 1614.

In the past, the property has wrongly been called the Raven Tavern. This tavern actually stood in Southgate Street. The confusion may have arisen due to a family connection. Leonard Tarne was married to one of Charles Hoare's daughters. Amongst his many possessions in his will of 1641 he bequeathed the 'noted Raven Tavern'. He may have inherited this through marriage.

In 1950 the building was extensively restored with some alterations for trustees of the Raven Fund by H. F. Trew, with support from the Society for the Protection of Ancient Buildings. A large part of the interior now reflects those alterations. It is now used as an old people's centre.

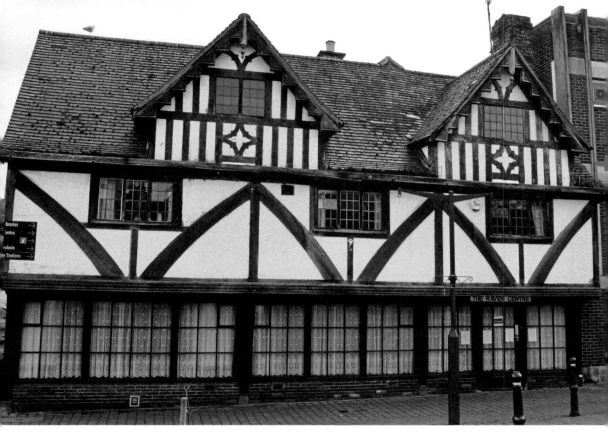

The impressive frontage of the building known locally, but erroneously, as the Old Raven Tavern in Hare Lane.

17. Robert Raikes' House, No. 38 Southgate Street

This historic building was home to the *Gloucester Journal*, a newspaper started by Robert Raikes the Elder and published from these premises in 1725. Robert Raikes the Younger inherited his father's business and in 1758 transferred the printing of the newspaper back to Southgate Street from Blackfriars, where his father had moved it to in 1743. By 1772, Robert Raikes and his family had made it their home. Robert Raikes later became famous for being known as the founder of the Sunday school movement.

From 1973, it became the Dirty Duck Restaurant and from 1975, the building was a public house called the Golden Cross until it closed in the late 1980s. In 2007, it was lovingly restored by the Oak Frame Carpentry Co. Ltd on behalf of Samuel Smith's Brewery, retaining the front three cross-gabled bays jettied on the first, second and attic floors. It is now a public house.

Opposite above: The exquisitely restored house of Robert Raikes in Southgate Street.

Opposite below: Three sugar loaves, suspended from a cast-iron bracket outside the pub, is a sign that it used to be a grocer's shop.

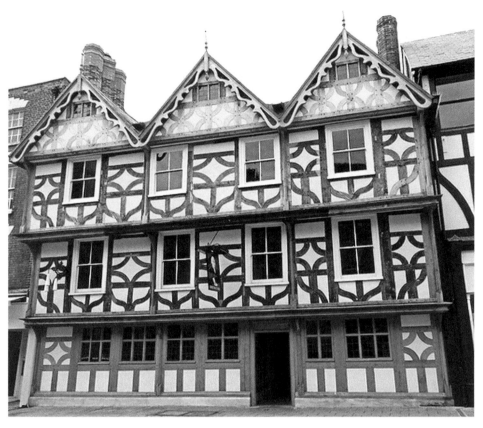

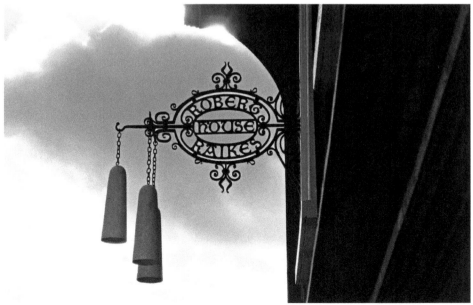

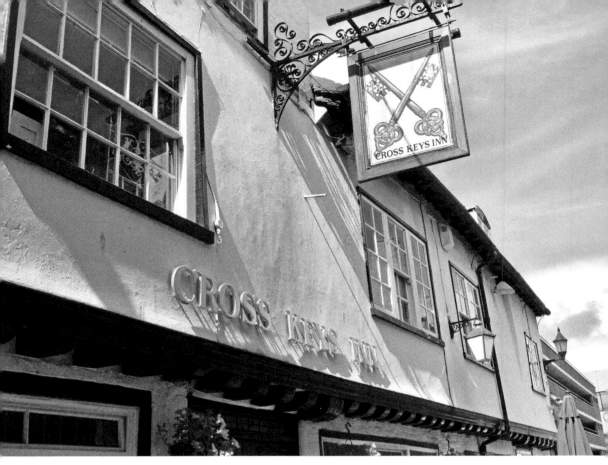

The front of the Cross Keys Inn, showing the continuous jetty supported by the exposed ends of the first-floor cross-beams and joists.

18. Cross Keys Inn, Cross Keys Lane

The Cross Keys Inn is in an early to mid-sixteenth-century Grade II-listed timber-framed building, which was originally three cottages. It appears in licensing records by 1720, so has a long tradition of being a public house. In medieval times, the sign of the crossed keys meant that the inn was supplied by a nearby monastic house. It is also the emblem of St Peter, suggesting a connection between the inn and St Peter's Abbey (Gloucester Cathedral).

It is a long, end-gabled range of five bays with a continuous jetty at the front. There are areas of exposed timber-framing within the building.

19. Gloucester Life Museum, Upper Westgate Street

One of the most iconic historic buildings in Gloucester, and beautifully preserved both inside and out, the Gloucester Life Museum is well worth a visit. Bishop Hooper is said to have spent his last night on this earth in this building when he was brought to Gloucester to be burned at the stake in front of St Mary's Gate on 9 February 1555. The building was

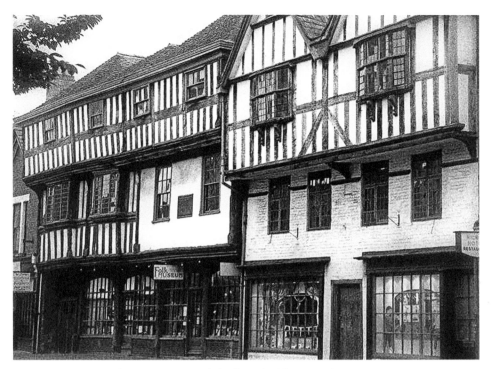

Above: Gloucester Life Museum, one of the finest buildings in Gloucester.

Below: The remains of a wall painting, depicting white grotesques on a black background, inside the Life Museum.

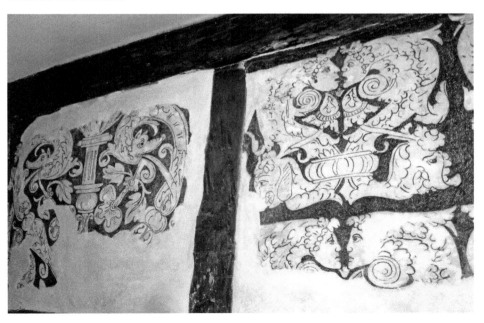

also believed to be have been owned at one point by John Deighton, a local surgeon; the house was bequeathed to his daughter Damaris Deighton in his will of 1640.

The building is timber-framed with jettied upper floors. When, in 1993, rendering was removed from the second floor, they discovered original timber-framing in the cross gables.

20. The Old Bell, No. 9 Southgate Street

This Grade I-listed building has a magnificent Jacobean timbered facade. It was built around 1665 for Thomas Yate, apothecary and mayor of Gloucester. Thomas Yate was a younger son of the Yate family, whose family home was at Arlingham. The property is noted for its oak-panelled rooms, where fine traces of colour in the grain of the oak have shown that this woodwork was once painted an orange russet colour.

In the nineteenth century the property was known as the 'Old Blue Shop', when it was the property of a blue maker named James Lee. Blue makers manufactured a species of blue dye, principally used by calico printers. Traces of a dark grey-blue substance have been found on the facade and under the floorboard.

In 1782 John Phillpott moved to Gloucester, where he became the landlord of the Bell Inn, which at that time was the headquarters of the Tory True Blue Club, founded in commemoration of John Pitt's victory in 1789.

The second-floor finely carved, stone fire surround depicting a pair of lions and a prone sheep.

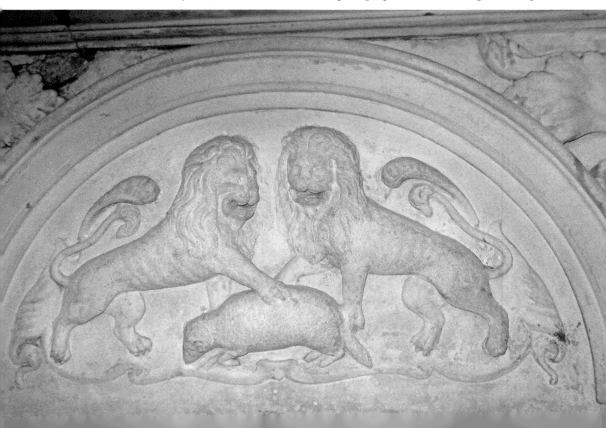

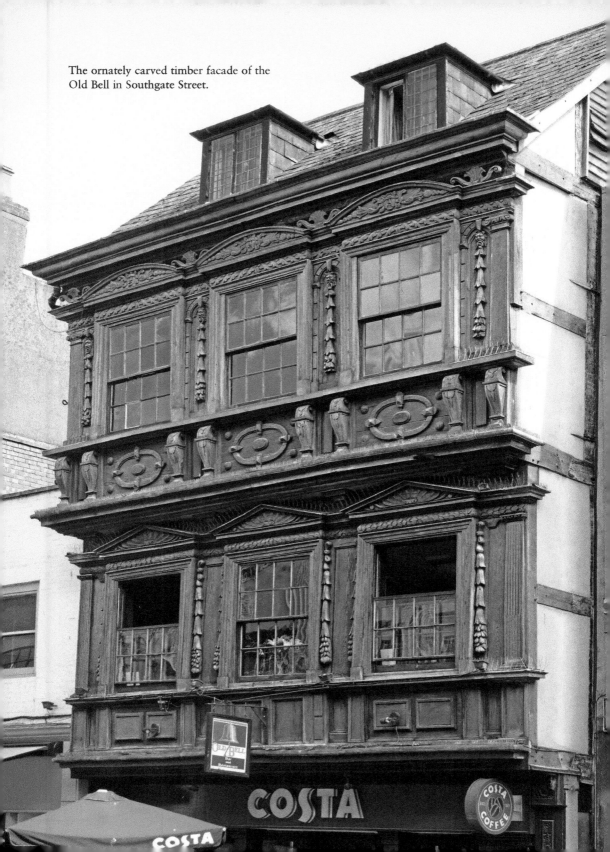

The ornately carved timber facade of the
Old Bell in Southgate Street.

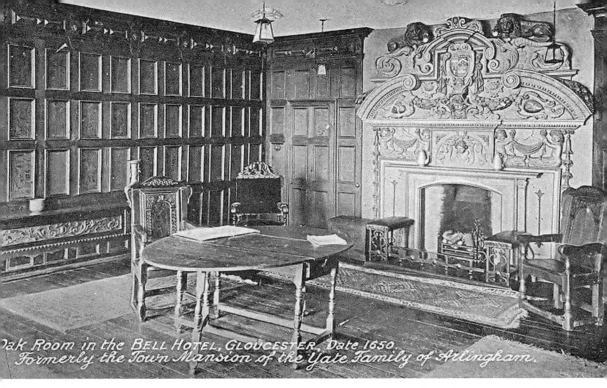

Oak Room in the BELL HOTEL, GLOUCESTER. Date 1650.
Formerly the Town Mansion of the Yate Family of Arlingham.

An old postcard of the Oak Room in the Old Bell, showing the magnificent fireplace with oak panelling, which dates to 1650.

The main feature on the first floor is a magnificent moulded fire surround. Dating from the mid-nineteenth century, it features cherubs and cornucopia with the coat of arms of Yate crossed with Berkeley, and is dated 1650. It is thought to commemorate the marriage of Thomas Yate. On the upper floor is another very fine carved stone fire surround, this time featuring a pair of lions, underneath which lies a sheep. It is all enclosed within a tympanum frieze with foliate and floral carving.

It has been suggested that the building may have been constructed using timber from the *Mayflower*, the ship that took the Pilgrim Fathers to America, but how this supposition arose is unknown.

21. Old Custom House, The Quay

In 1580 Elizabeth I granted Gloucester formal status as a port. The following year, a timber-framed house was built. By 1725 the Old Custom House had been built, which had a store at ground level and offices above. This building was in use from 1725 until the volume of trade made it necessary to build a new Customs House in what is now Commercial Road.

It is a narrow rectangular block; the upper floors of the eighteenth-century addition to the front are supported on a colonnade facing the quay. The colonnade has two slender cast-iron columns between ashlar corner piers. Set centrally on the front between the first and second floors, there is a weathered stone panel, carved with the royal arms.

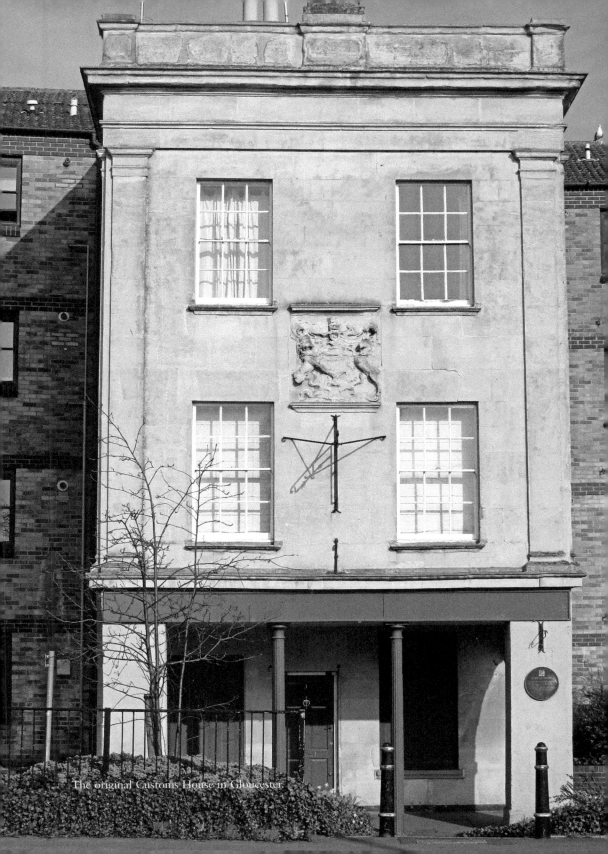

The original Customs House in Gloucester.

22. Mercers' Hall, Cross Keys Lane

Built in 1778 as a bonded warehouse for wines and spirits, this building is now Gloucester's masonic hall. Although the building does not appear on maps until the later 1700s, the first floor and roof structure has been dated by dendrochronology to between 1495 and 1500. These timbers are believed to have been removed from a market hall that would have stood elsewhere in the city. The scale of the timbers in the roof, the first-floor framing, and the central row of supporting posts suggests that they may all originate from the same building, supporting the received tradition that this was the former Mercers' Hall, which would have been used for meetings.

By 1810 the lower floor was occupied by a local cider merchant and brewer who used the upper floor as a granary. In 1898 the warehouse was purchased by the well-known local firm Washbourn Brothers who used it as a bonded store for wines and spirits. In 1926 Charles Urch converted the store into a function room and dance hall. It is still said that the building boasts the finest dance floor in Gloucester. The upper floor is now used as the Mason's Temple, complete with the chequered floor and the all-seeing eye in the roof space.

The all-seeing eye of the Freemasons, occupying a space in the medieval timber roof trusses.

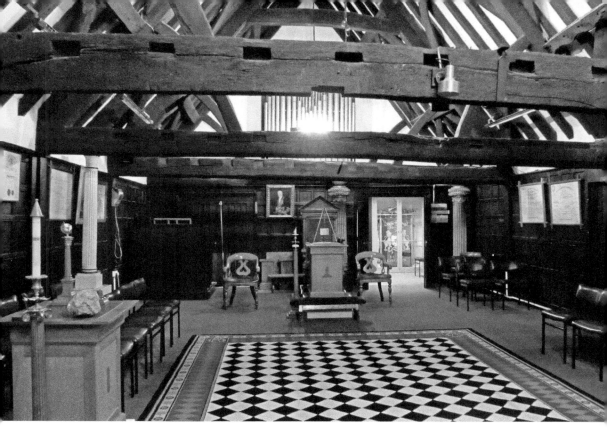

An interior shot of the room used by the Freemasons for their ceremonies, complete with a black and white chequered rug and oak panelling from the twentieth century in a seventeenth-century style.

23. HM Prison, The Quay

The building of the prison began in 1784 by William Blackburn and was finished in 1790. The prison was designed on principles advocated in 1777 by John Howard in his report 'The State of the Prisons' and marks an important phase in the history penal reform. The principles were recommended to a Grand Jury at Gloucester in 1783 by a committee headed by Sir George Onesiphorus Paul for the construction of five new county gaols in Gloucestershire. This is the only part of Blackburn's work to remain in Gloucester. It was finally completed around 1810 by John Wheeler, the county surveyor, for the county magistrates. It was further enlarged in 1826 with additional buildings and perimeter walls by John Collingwood, and again further enlarged and altered between 1845 and 1855 by Thomas Fulljames. These 1844 additions are impressive in their own right and employ a richer classicism than the Pentonville designs upon which they were based.

The outer gatehouse was built in 1826 by John Collingwood for the county magistrates. Above the entrance doors is an iron portcullis and to the side of these are two small cell windows with stone frames now bricked in.

Inside the central entrance block there is a stairwell with cast-iron stairs rising to cast-iron, balustraded galleries, with lion's paw upright posts and twisted snake brackets. This gives access to a row of cells on each side of a central, open well within each wing.

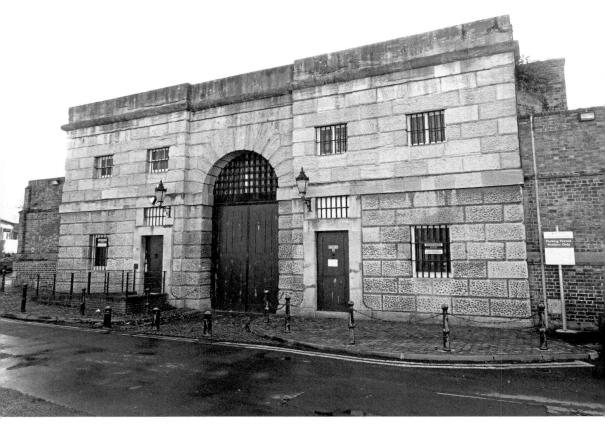

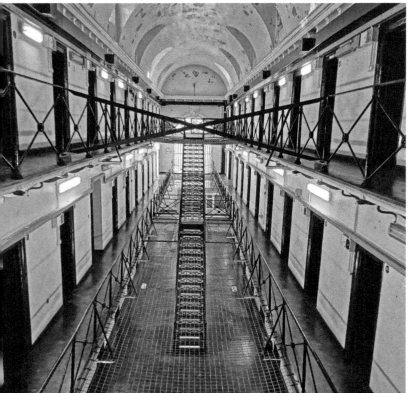

Above: The main entrance to the prison, showing the iron portcullis above the double doors.

Left: The interior of HM Prison, showing the cell blocks.

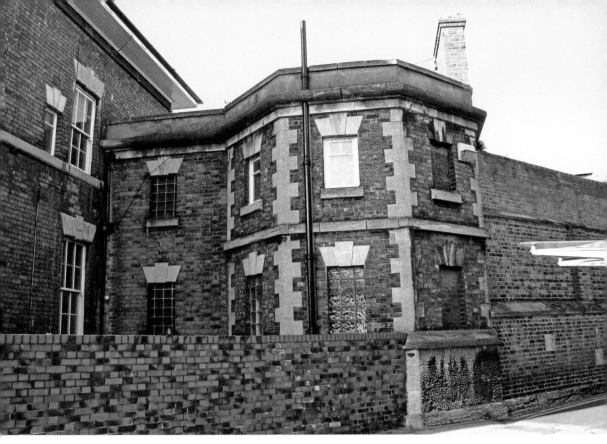

The grim-looking, former Governor's house at Gloucester Prison.

A new young offenders' wing was built at the prison in 1971. Further improvements were made in 1987, including a new gate, administration block and a visitor centre. The prison finally closed in 2013 and has recently been bought by City and Country, a development group specialising in the conversion of listed and historic buildings for residential and commercial uses.

The prison was built upon the site of Gloucester's original twelfth-century Norman castle. In 2016, while carrying out archaeological investigations, the remains of a huge medieval castle was discovered under the basketball court of the former prison, thought to be the 'tower keep', which is believed to date back to 1110.

24. Nos 182–184 Southgate Street

Of all the houses I have chosen to be in this book, this is my 'mystery house'. Little is known about who it was built for and why. The front of the building is distinguished by remarkable wooden arrows underneath the window openings. The arrows are decorated with sail cloth carvings and are thought to have been made in 1851 and to have originally come from a whaling ship. A shipmaker is thought to have placed them there, possibly the owner of the building. Canvas and sail merchants, ship's carpenters and master mariners are all recorded as having lived in Southgate Street during that time.

No. 184 Southgate Street, distinguished by remarkable cast-iron draped arrows.

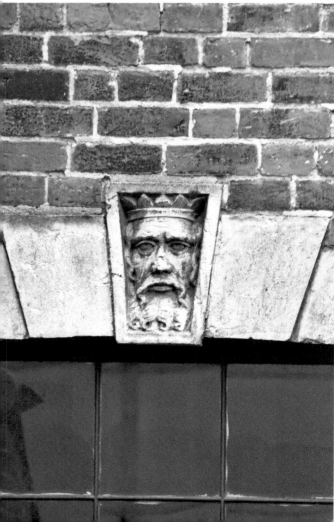

Unusual stone mouldings at the rear of No. 184 Southgate Street. This one depicts a bearded man wearing a crown, possibly an English king.

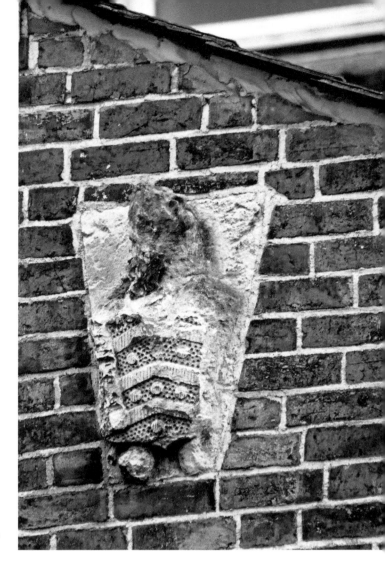

This badly weathered carving shows the city's coat of arms, granted in 1652 of three chevrons between ten torteaux, or red discs.

But it is the rear of the building that is fascinating. Several carved keystones are present there, depicting the city's coat of arms, a man wearing a crown and another figure possibly depicting Poseidon, Olympian God of the Oceans and king of the sea gods or his Roman counterpart, Neptune. All of this could indicate a naval connection, the property being in close proximity to the docks.

25. Crown Court, Longsmith Street

This building was designed by the notable Sir Robert Smirke, who was a leader of Greek Revival architecture. He also designed Shire Hall and Westgate Bridge. It was originally used as an Assizes, then later a Quarter Session and also a County Court. It is now used as a Crown Court. It was built in 1816, using an unusual design of a polygon of nine equal facets, in the Severe Classical style, characterised by an absence of architectural details.

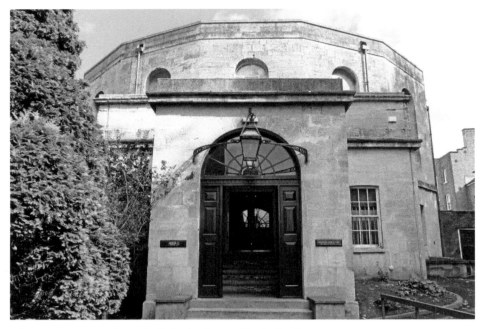

Gloucester's Crown Court, built in the Severe Classical style.

26. Beaufort Buildings, Spa Road

Beaufort Buildings is a terrace of three houses built in 1818 for the Gloucester Spa Company. They were amongst a number of fine buildings built in Spa Road during the heyday of the short-lived Spa.

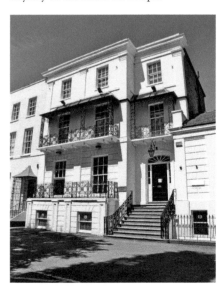

Beaufort Buildings in Spa Road. Each house has an identical entrance with an Ionic porch.

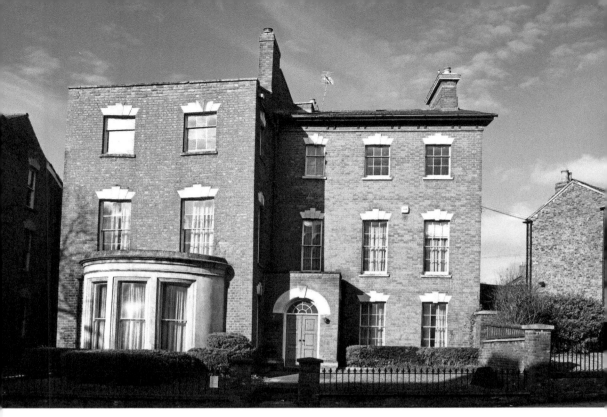

Bastion House, so called because it was built on the site of the bastion, constructed to defend the City of Gloucester in the Civil War siege by Royalist Forces.

27. Bastion House, Brunswick Road

This property takes its name from the site of the bastion at the south-east corner of the defences, which were constructed from 1644 to 1651 to defend the City of Gloucester in the Civil War siege by Royalist Forces.

In the nineteenth century, a bow window in ashlar was added to the front of the property.

28. Christ Church, Brunswick Road

Thomas Rickman and Henry Hutchinson built this parish church in 1822 in response to the growing numbers of people occupying houses in the Gloucester Spa development area.

The building has undergone several alterations over the years. The chancel was enlarged and the north vestry was added in 1865. There were further internal alterations in 1883. The west front was rebuilt in a monumental Italian Romanesque style adding a twin arched bell-cote, complete with twin bells. From 1899 to 1900, alterations by Henry Prothero included replacing the original flat ceiling with a central barrel vault which terminates in a semi-dome within the apse. The apse was decorated in 1911 with a mural of angels in the art nouveau style. Most of the windows in the aisles retain stained glass with an all-over honeysuckle motif, contemporary with the original building.

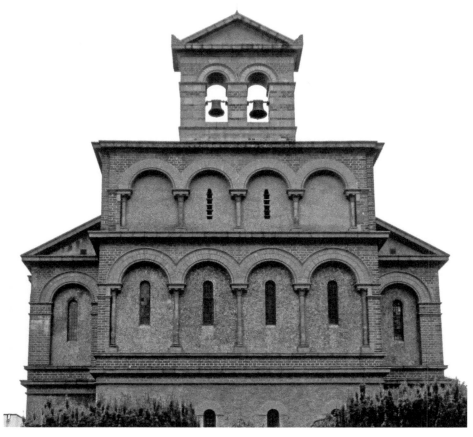

Above: The Italian Romanesque frontage of Christ Church.

Below: The interior of the church showing the central barrel vault over the nave.

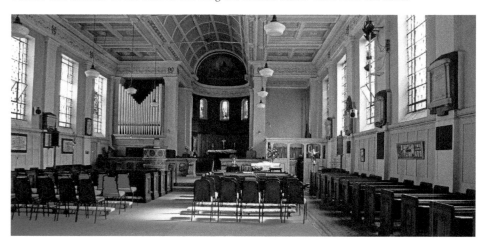

29. Nos 19–21 Spa Road, Cass Stephens Insurance

Probably built during the building boom of the Spa development, this pair of semi-detached houses are distinguished by their colourful, nineteenth-century verandas. The front of the verandas have a Chinese pattern of glazing bars in most of the upper panels. Until recently, the roof of the veranda to No. 19 still had its original spade-shaped zinc tiles but these have been replaced with glazing.

The colourful verandahs of Nos 19 and 21 Spa Road.

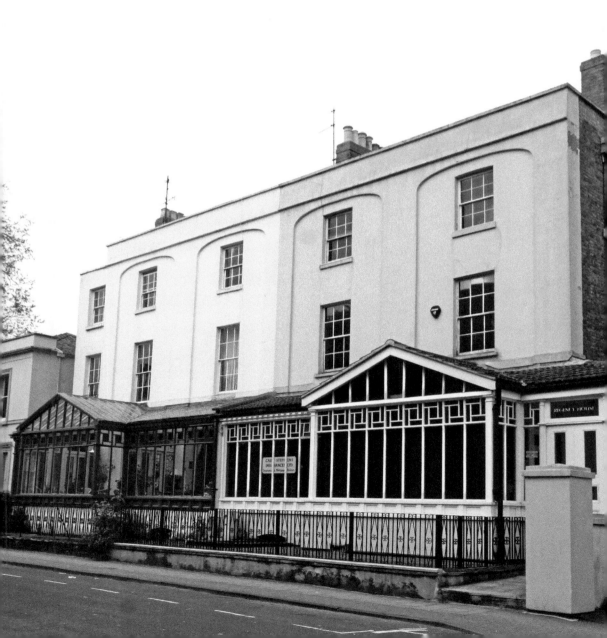

30. Ribston Hall, Spa Road

Ribston Hall began life as the Spa Hotel, originally built for John Phillpotts, a local barrister and later MP for Gloucester, as a hotel for visitors to the Gloucester Spa.

An impressive frontage of five symmetrical bays, each bay having an arcade, decorated with a Greek Revival pattern channelled into the stucco with horizontal panels of incised Greek key pattern linking the window openings. Each window has a recessed tympanum decorated with a simple, repeating, incised pattern. The six-panelled entrance door has a raised keystone in the arch carved with the face of a bearded man, whose identity is unknown. There is evidence of the existence of a porte cochère, a portico-like structure through which a horse and carriage would have been driven, from the retained, flanking pilasters either side of the doorway.

Elizabeth Barratt Browning was a guest in the former Spa Hotel. She spent a year in the city during her convalescence from an illness which caused her intense head and spinal pain and loss of mobility.

In 1860 it became a college for young ladies called Ribston Hall, and in 1970 it was altered for use as an art school annexe. It has recently been converted into private apartments.

Ribston Hall, formerly the Spa Hotel, now private apartments.

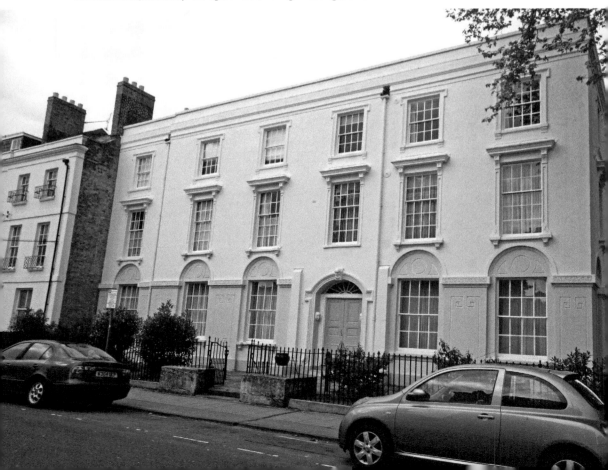

31. Albion House, No. 77 Southgate Street

Albion House was built on the site of the old Squirrel public house in 1831. The plans were drawn up by local architect Thomas Fulljames Junior to a very high specification. The plinths and steps were to be made from the very best Forest stone and the windowsills and other stonework were to be in Bath or Painswick stone. The client was the government of the Gloucester Infirmary, who commissioned the 'Commercial Inn' on a speculative basis, complete with brewhouse, tap room, smoke room and stable yard.

Built in the Severe Greek Revival style, it has a symmetrical, five-bay facade of Bath stone. The ten classic square Doric columns or pilasters have the ornamental egg-and-dart decoration below each of the columns, typical of the Regency era and also to be found in Ancient Greek architecture. Its ovoid shape (the egg) and serrated leaf (the dart) are believed to represent the opium poppy and its leaves.

By today's standards we would find it wholly inappropriate for a health provider to open a commercial hotel for the purposes of drinking and smoking! It was presumably to raise money for the infirmary before the creation of a National Health Service.

The hotel was sold by auction in 1933 by the Stroud Brewery Company. The building is now being converted into private apartments.

Albion House, formerly the Albion Hotel, built as a commercial venture by the Government of Gloucester Infirmary.

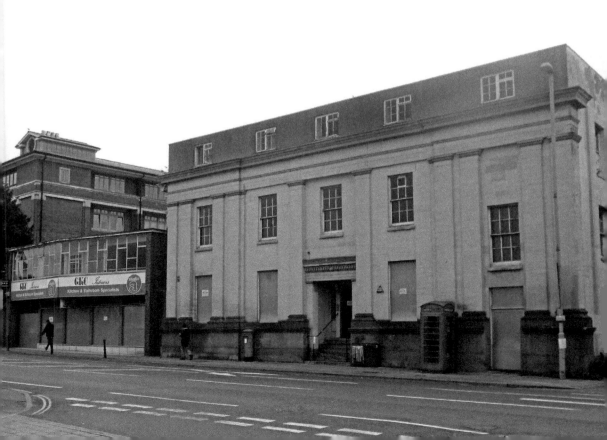

32. The Custom House, Soldiers of Gloucester Museum, Commercial Road

The new Custom House in Commercial Road was completed in 1845 to a design by architect Sydney Smirke, who was the brother of the better known Robert Smirke. It was built to replace the Old Custom House, which was too small and remote to cope with the great expansion of foreign trade passing through the Port of Gloucester. Thomas Haines & Son were the contractors.

A classically symmetrical design, it is faced in Painswick stone with distinctive large corner quoins of stone at each end. Set above the centre of the parapet is the Royal Coat of Arms worth noting in some detail.

The shield is quartered, depicting in the first and fourth quarters the three passant guardant lions of England. In the second, the top right quarter, the rampant lion and the 'double tressure flory-counterflory' of Scotland. The third, bottom left quarter, a harp for Ireland. The belt surrounding the shield bears the motto of the Order of the Garter, an ancient order of knighthood of which the Queen is Sovereign. The motto is in French and reads '*hon y soit qui mal y pense*', meaning 'Shame to Him Who Thinks Ill of It'. Below that is the motto of the Sovereign, which reads in French '*dieu et mon droit*', meaning 'God and My Right'.

The dexter (or right-hand side) supporter is usually of a crowned English lion, although in this case the crown is either missing or absent. The left-hand side, or sinister supporter, is that of the Scottish unicorn. According to legend, a free unicorn was considered a very dangerous beast, therefore the heraldic unicorn is chained, as in this depiction, although again the unicorn's spiralled horn is also missing. In the greenery below a thistle, representing Scotland, and a Tudor or Union Rose, representing England can be seen. There should also

The front of the new Customs House, now the Soldiers of Gloucestershire Museum.

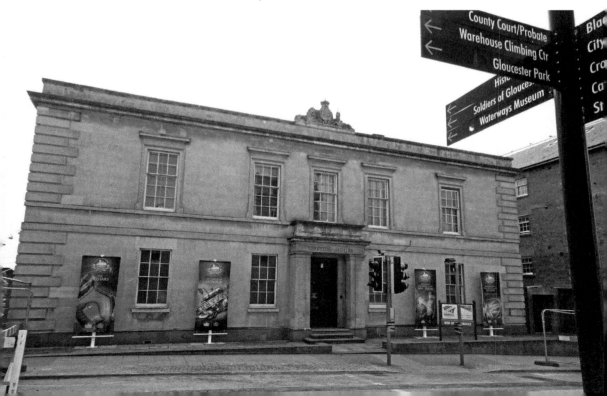

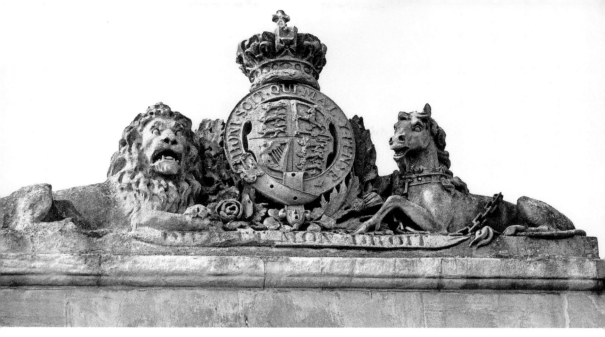

Detail of the weathered stone decoration on the top of the building.

be a shamrock, representing Ireland, however, the shamrock is no longer visible, probably to environmental erosion. Above all of this sits the royal crown with *crosses patée*.

When the building was completed it was occupied by the Collector of Customs and his staff, who were responsible for recording cargoes brought to Gloucester from foreign ports and for collecting the customs duty payable on those goods. Although the handling of foreign cargoes moved to Sharpness, Gloucester's Custom House continued as an administrative office until the late 1970s. The building then became the headquarters of the Gloucestershire Regiment, including the regimental museum, the Soldiers of Gloucestershire Museum, which was opened in 1980 by HRH Duke of Gloucester, Colonel in Chief of the regiment.

33. Shire Hall, Westgate Street

The original building, of which only the portico remains, opened in 1816. It was built on the site of the old Booth Hall. A blue plaque on the side of the building states:

> Until 1957 here stood The Booth Hall, mentioned in 1230, it served as a Guildhall, Assize Court, Theatre, Concert Hall and finally Cinema. Here Shakespeare probably acted, M.P.s were elected and George Whitfield preached.

It was built for the County Magistrates and designed by Sir Robert Smirke who also designed Westgate Bridge and the Crown Court in Longsmith Street. Substantial extensions to either side of entrance front were undertaken between 1909 and 1911 by M. H. Medland, a local architect who became county surveyor. Between 1960 and 1970 most of the building was demolished retaining only the entrance portico and the flanking wings. The giant Ionic portico built in 1816 is of particular note.

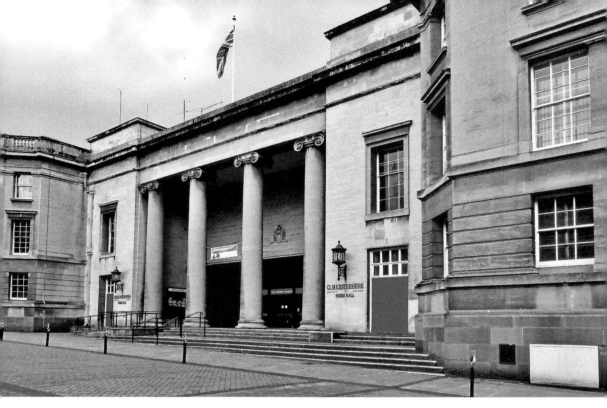

Above: The entrance to Shire Hall with its impressive entrance, showing the Ionic portico of three bays.

Below: The Ionic column in closer detail.

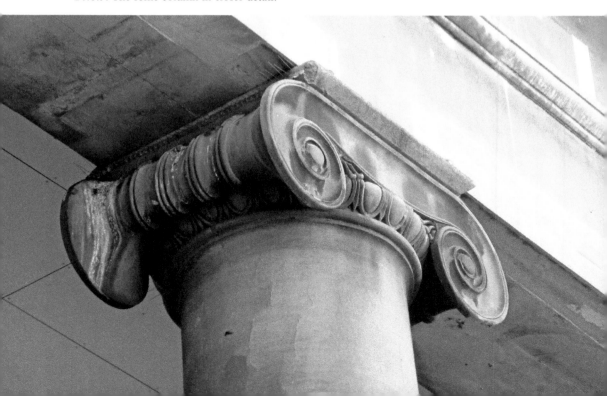

34. Friends' Meeting House, Greyfriars

The Society of Friends, or the Quaker movement, was evident in Gloucester from 1655 when a meeting at Thomas Ridell's house was recorded. Although a relatively tiny group in Gloucester, the Quakers were a very visible minority, mainly because of their dress, speech and repudiation of many of the social conventions. They had their own meeting house, which was originally two cottages and, equally important, their own burial ground. They followed the Quaker pattern and conducted their own marriages and funerals.

Friends' Meetings had been held at Park Street Mission Room until 1834 when they built their own meeting house in Greyfriars. It was designed by local architect, Samuel Whitfield Daukes. Later in 1879 a large portico was added to the front of the building, with a schoolroom above. A unique internal feature is the large wooden screen between the two main rooms which can be wound up and down to make one large space.

The classic simplicity of the Friends' Meeting House.

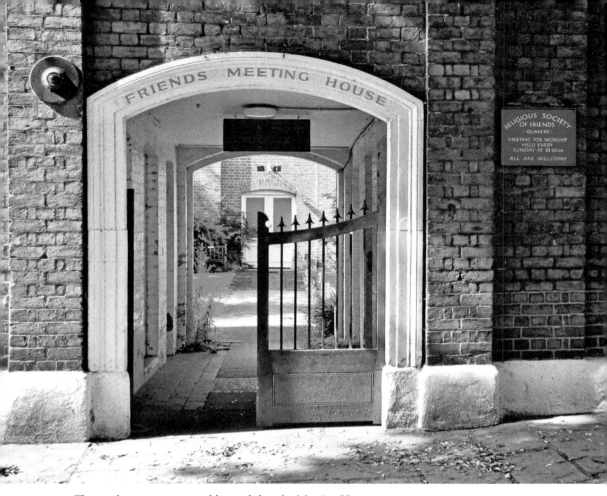

The gatehouse entrance and beyond that the Meeting House.

35. Pillar and Lucy Warehouse, Merchants' Road, Baker's Quay, Gloucester Docks

In 1826 the Gloucester and Berkeley Canal Company began building the first of the large warehouses which were to be the dominant architectural feature of the docks. Bonded warehouses, built for Gloucester's timber and corn merchants, sprang up to meet the growing demands of industry. The Pillar and Lucy warehouse was built in 1838 by Samuel Whitfield Daukes. The warehouse comprised of two parts. The northern warehouse was built for Samuel Baker, who imported sugar and other produce from the West Indies direct to Gloucester and the southern warehouse was for J. M. Shipton, a timber merchant.

The warehouse is distinguished by a row of seven substantial cast-iron Doric columns supporting beams under the upper floors at the rear of the building. Internally, there are several hollow cast-iron columns supporting timber floors with beams believed to be 28 metres long.

The warehouse has recently undergone renovation and now houses a restaurant.

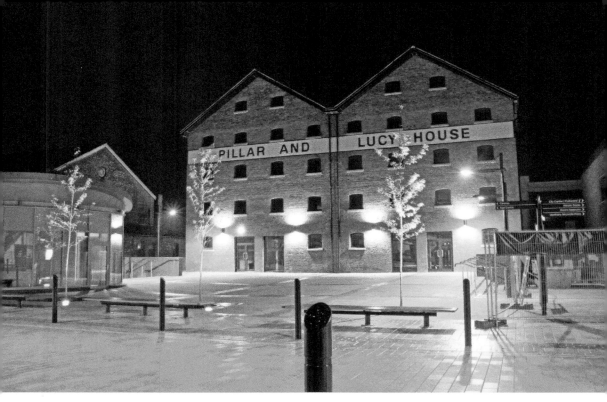

Above: The frontage of the newly refurbished Pillar and Lucy warehouse, lit up at night.

Below: The rear of the warehouse fronting onto the canal at Baker's Quay.

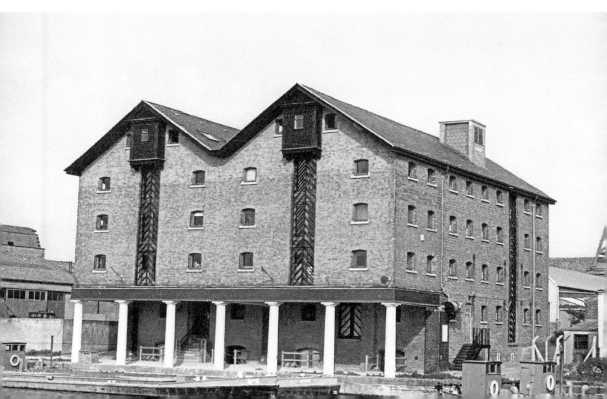

36. Lampkin House, Commercial Road

Lampkin House was once the home of the great Gloucester Savings Bank. It was built in 1849 by John R. Hamilton, a local architect and James Medland, who became county surveyor for Gloucestershire. It was specially designed to fit the triangular site at the junction of Commercial Road and Southgate Street.

Designed in the Italianate style, it has distinctive sculpted keystones depicting unusual faces, including a man with a crown made of bricks, another with entwined snakes in his hair and a woman with sheaves of corn in her hair, all thought to be symbols of fertility and presumably monetary fruitfulness.

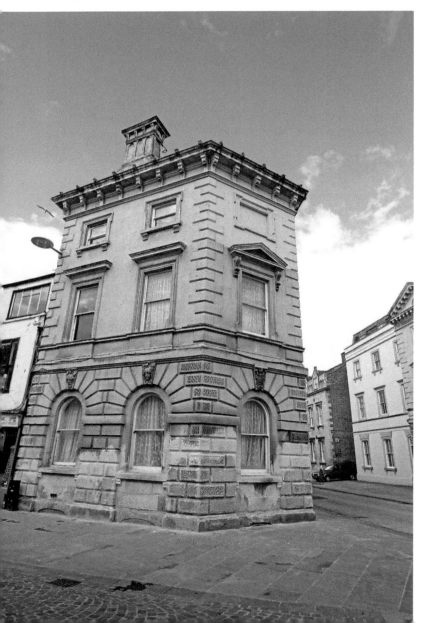

The former Gloucester Savings Bank building, now known as Lampkin House.

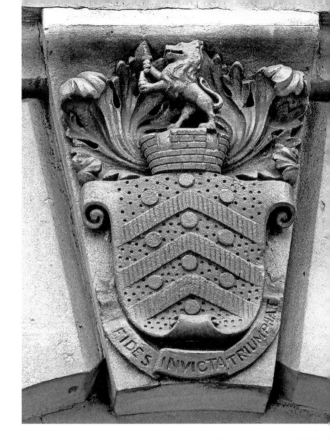

The keystone above the door of Lampkin House.

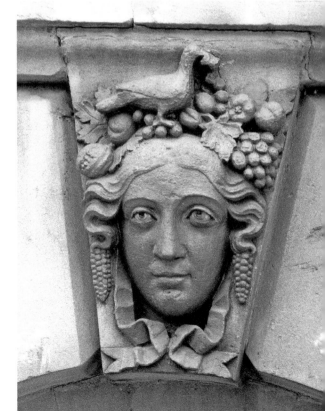

The face of a woman with braided hair and a bird on her head among fruit and foliage.

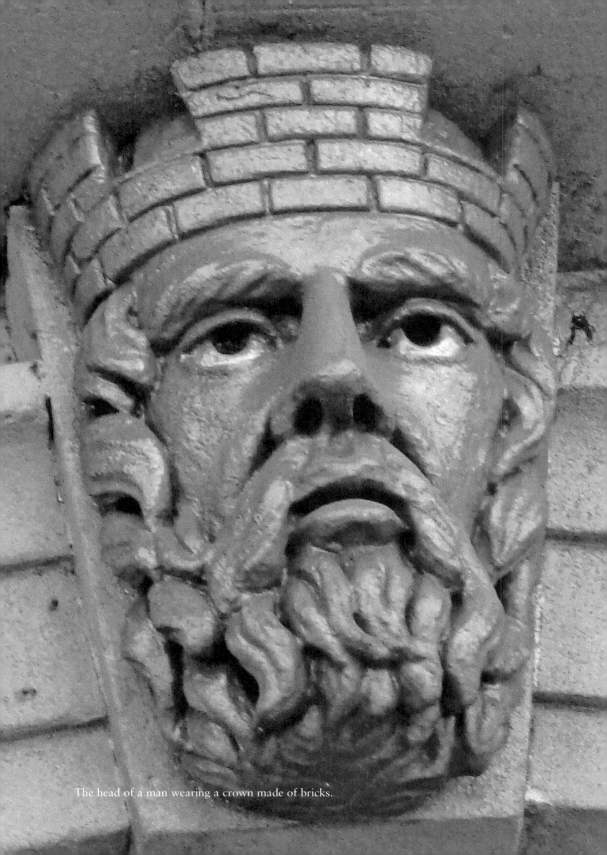

The head of a man wearing a crown made of bricks.

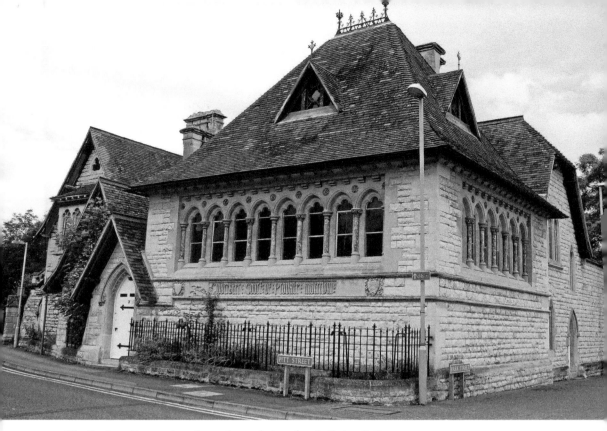

The Probate Court, virtually unchanged since first built in 1858.

37. Probate Building, Pitt Street

Formerly the Court of Probate, this unique building was designed by local architects Fulljames and Waller and completed in 1858. Built using rock-faced rubble with dressed stone features, it has a steeply pitched, hipped roof with two unusual, triangular dormers. The style of architecture is known as Picturesque Gothic with its two storeys designed for romantic medieval effect. The other interesting feature of this building is the arched windows with trefoil heads and brown, marble shafts in between.

On the side of the building is an inscription in a stone panel in raised Gothic lettering: 'Gloucester Court of Probate MDCCCVIII'. Next to this is the city's coat of arms.

38. Addison's Folly, Greyfriars

This folly is the only surviving portion of a former house on the south side of what was Bell Lane. It was built in 1864 for Thomas Fenn Addison, a local lawyer. Composed of ashlar with dressed stone, some of the masonry probably survived from the medieval period and some from the demolished parts of the Franciscan Friary of Greyfriars nearby. The folly is a tower of three tall storeys, which has on all its sides a crowning cornice and crenelated parapet.

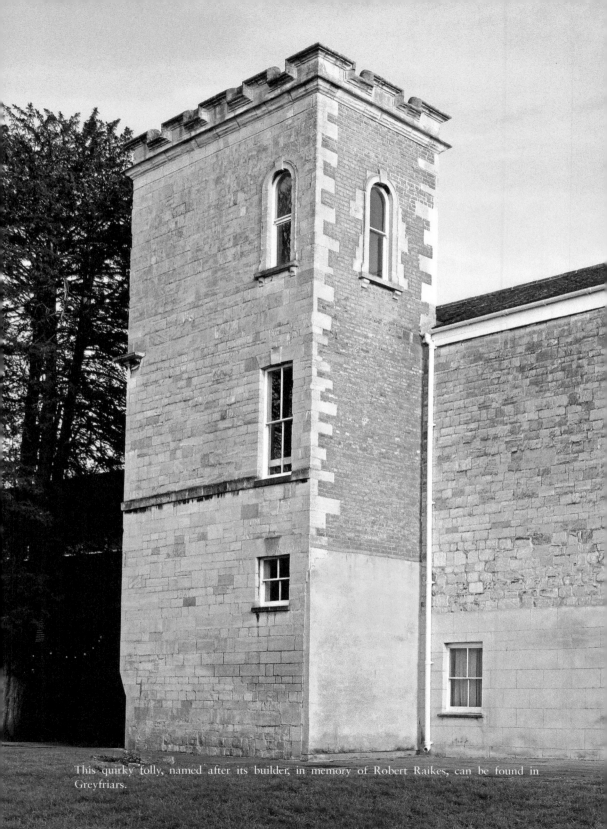

This quirky folly, named after its builder, in memory of Robert Raikes, can be found in Greyfriars.

The plaque attached to the west wall gives a hint at the history of the folly. It is inscribed:

ADDISON'S FOLLY was built in 1864 by Thomas Fenn Addison in memory of Robert Raikes who, together with Thomas Stock (both pioneers of the Sunday School Movement), in 1780 started a Sunday School to teach poor children to read.

39. Moreland's Match Factory, Bristol Road

An indenture dated 29 August 1868 was drawn up following the death in 1844 of Samuel Jones. His son William Jones, the only surviving son, was a trustee of the will. In the will, it stated that he 'should make sale and absolutely dispose of all and every [of] his real estate'. So in 1868 a contract to sell parcels of land in Bristol Road was drawn up between William Jones; William Brown Clegram; Samuel John Moreland, a Saw Mills Proprietor; and John Smart, the City Contractor. This indenture established a match manufacturing concern in Gloucester which was to continue until 1976 when the factory on Bristol Road closed down.

Samuel John Moreland first started making lucifer and vesta matches. Lucifer was an old-fashioned word for the first type of matches made using sulphur, which had an initial violent reaction, an unsteady flame and unpleasant odour and fumes. In 1885 the industry employed over 1,000 outworkers, chiefly women and children, making matchboxes in their own homes. In 1897 the factory was described as 'efficient and well-equipped' for the period. In 1911 the company began extensive factory rebuilding and when the work was completed in 1912 they had installed the first continuous automatic match-making machinery. Further building took place in 1919, introducing more advanced automation and reducing the workforce. Matches were transported by horse and carriage until 1919, when they were replaced by motor vehicles.

Moreland's are famous for their range of England's Glory matches, trademarked and registered in 1891, showing the battleship HMS *Devastation*, which was launched in 1871. Some time prior to the First World War, the company came up with the idea of putting jokes on the matchboxes as a way of promoting the brand and beating off competition.

The business was acquired by Bryant & May in 1913 but remained under the management of the Moreland family. By 1967, their centenary year, the factory was producing 50 million matches each working day.

Bryant & May reduced the match factory to branch status in 1972 and in 1976 it was closed to centre production on Liverpool and Glasgow, and 280 jobs were lost.

Moreland's were noted for providing good working conditions for their workers and subsequently had a tradition of long-service employees. Mr Pritchard, a former City High Sheriff of Gloucester, racked up forty years of service in the company and was a keen phillumenist, a collector of matchbox or matchbook labels.

The factory was reopened as a trading estate in 1978. It still has the iconic image of the Moreland's sign which was put up in 1954 on the corner of the building. In 2010 a campaign was launched to relight the iconic 'England's Glory' sign, which had remained unlit since the seventies.

In 2015 Robert Moreland, the last in a long line from the Moreland family died. He had the sad task of being the last to leave the Bristol Road factory when it closed in 1976.

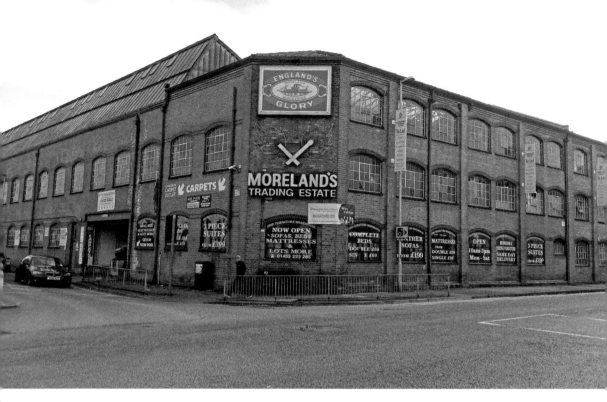

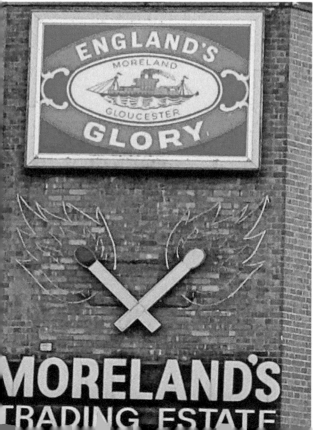

Above: Moreland's match factory as it looks today.

Left: This iconic image on the corner of the factory in Bristol Road has remained unlit since 1972.

40. Hillfield House, London Road

Hillfield House was built in 1867 for Charles Walker, a wealthy timber merchant of Price, Walker & Company. The builders were Albert Estcourt, a prominent builder of that time and the man who later gave his name to Estcourt Road in Gloucester, and William Jones, who also built the public library in Gloucester. The designer was the noted architect John Giles, who also designed Coney Hill Hospital.

Of particular note is the stunning interior of stone carvings of natural foliage and fruit; the stained glass by Lavers and Barraud, bronze railings manufactured in France; oak and mahogany doors and window frames; and a floor in the entrance hall of Sicilian and Black marble.

The stained glass above the main staircase bears the initials of the owner Charles Walker and the date of 1867. At the bottom of the window is the heraldic crest of the Walker family with the motto 'Cura et Industria', meaning 'Care and Industry'. The images in the glass depict events in Gloucester during the War of the Barons when Simon de Montfort led the struggle for power. Sir Roger Clifford had been Constable of the Castle and Sheriff of Gloucester, but he fell out of favour and in 1263 the king (Henry III) appointed Matthias de Besille to both posts. The local barons did not want a Frenchman in control of the city and elected Sir William Tracey as sheriff. When he was in office, Matthias took along a troop of men and burst into the court with drawn sword. Robert of Gloucester tells us that he took hold of Tracey by the head, threw him to the floor, bundled him out into the street and dragged him to the castle where he imprisoned him in irons.

Hillfield House on London Road, now a private residence.

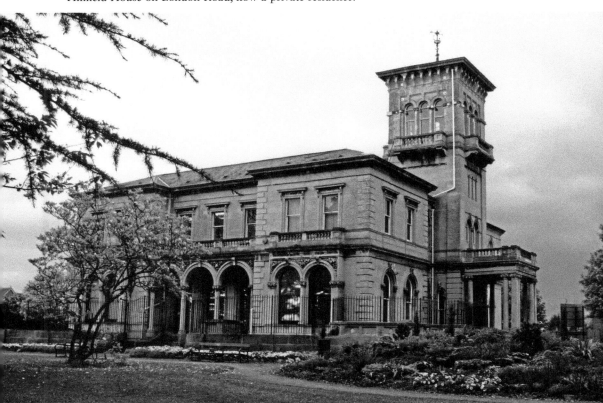

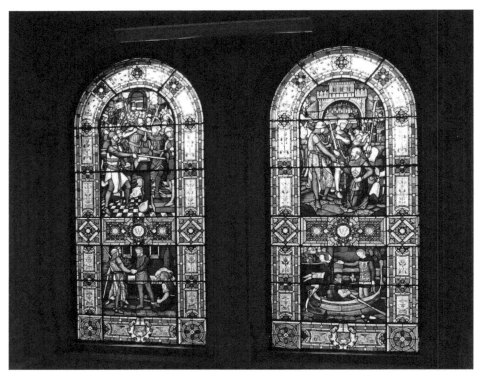

Above: The stained-glass window by Lavers and Barraud above the main stairwell.

Below: The magnificent atrium framed by bronze railings made in France.

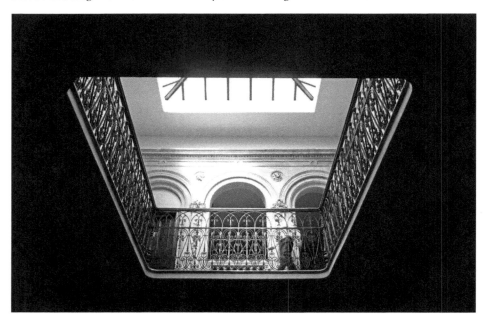

Externally, the building is faced with Bath stone and has a tall square tower with a viewing chamber, beneath which is a porte cochère, a structure through which a horse and carriage, or even a motor vehicle can pass in order for the occupants to alight under cover, protected from the weather.

41. Public Library and Museum, Brunswick Road

The Gloucester Literary and Scientific Association, founded in 1838 by prominent citizens, local gentry, and clergymen, organised lectures and acquired the city's principal library. County landowners, notably Thomas Gambier Parry, also figured in the movement to open schools of art and science in the city. From 1872 the schools were housed in a new building in Brunswick Road, paid for mainly by subscriptions and vested in the Gloucester Science and Art Society. This building became Gloucester's Public Library.

It was built by Fulljames, Waller and Son in the Gothic style of the thirteenth century, inspired by G. E. Street, who was a leading practitioner of the Victorian Gothic Revival style. The building was completed in 1872.

At first-floor level a panel inscribed 'Public Library' sits beneath a tall four-light window with trefoiled heads, above which is an armorial shield of the city's coat of arms.

In 1893 Margaret Price built a hall next to the library as a memorial to her husband William Edwin Price, who was MP for Tewkesbury and who died at the age of forty-four. The hall was originally for the use of the Gloucester Science and Art Society. In 1902 it was adapted for use as a museum and art gallery for the Corporation of the City of Gloucester.

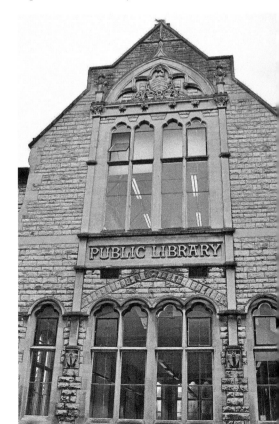

The thirteenth-century Gothic architecture of the public library, inspired by the work of G. E. Street, one of the leaders of the Victorian Gothic Revival style.

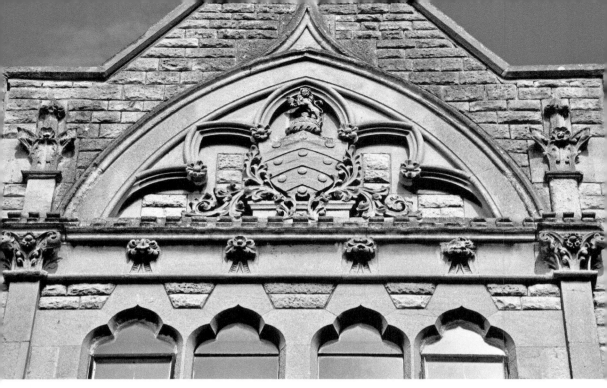

Above: Closer detail of the stonework featuring the city's shield.

Below: The city museum building.

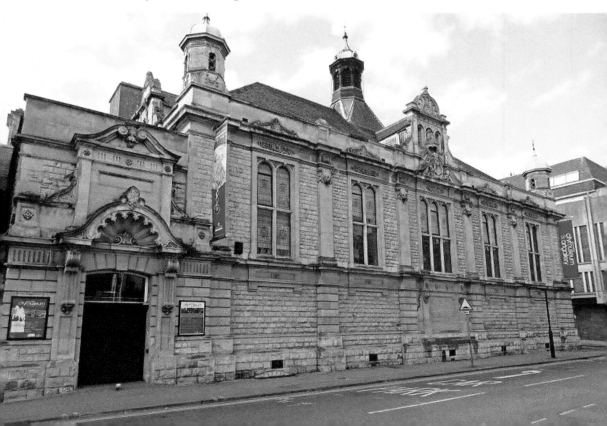

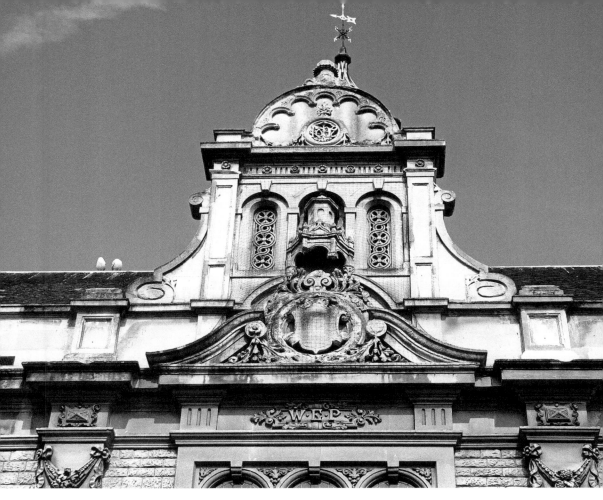

Above: The canopied entrance to the city museum. The initials WEP, referring to William Edwin Price, can be seen clearly above the entrance door.

Right: The three original sun-burner centrepieces. The original gaslights would have had a circle of burners whose light would have reflected off the convex centre.

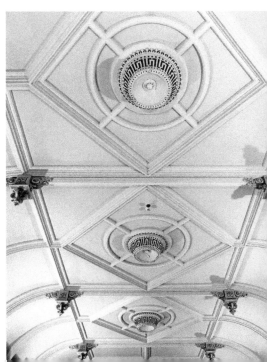

This hall was built by F. S. Waller in an eclectic early Renaissance style, inspired by the work of T. G. Jackson, who was one of the most distinguished English architects of his generation.

The most important internal feature of the 1893 hall is the main ceiling where the remains of the original gas light fittings can be seen with three sun-burner centrepieces. The internal staircase of 1898 is also of note. The interior also includes part of the scheduled Roman *colonia* wall.

42. Imperial Inn, Northgate Street

A public house on this site has appeared in licensing records since 1722. Originally named the Plough, the Imperial Inn was purchased by Mitchells and Butler in 1898. They rebuilt it with their typically elaborately moulded, glazed tile exterior. As such it is a fine example of a late nineteenth century decorative tiled frontage and the only one of its kind in Gloucester.

Above the entrance doorway is a moulded cartouche with flanking swags in a frieze panel, and to the left of that the words 'Imperial Inn'. On each of the tiled, vertical panels is the face of the Greek god Pan, with his customary horns of a goat, and complete with panpipes, which were named after him. Pan is the god of the wild, shepherds and flocks, nature of mountain wilds and rustic music, and companion of the nymphs to give him his full name, although why he should be chosen to decorate the Imperial Inn is a mystery.

The glazed, decorative tiled frontage of this little gem of a building in Northgate Street.

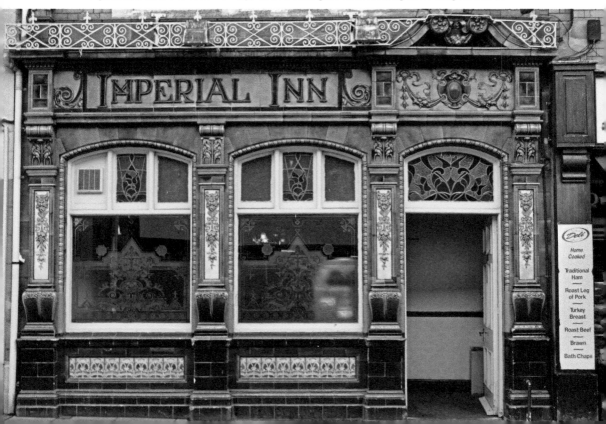

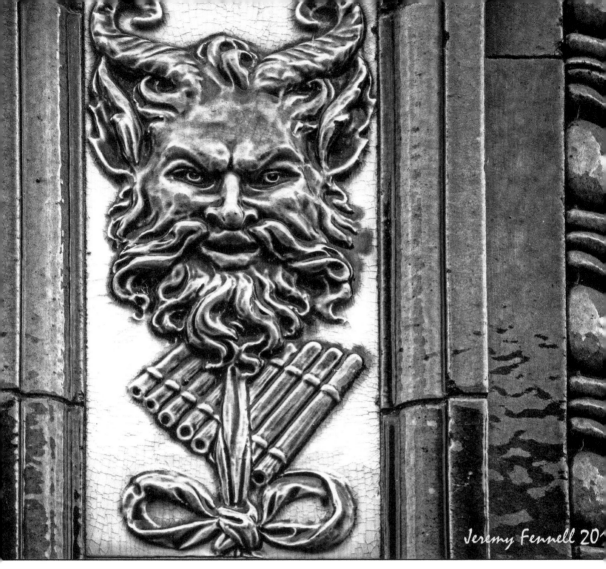

Jeremy Fennell 20

The Greek god Pan with pipes that were named after him, adorning the tiled frontage of the Imperial Inn.

43. Guildhall

The Guildhall was built between 1890 and 1892 by George H. Hunt for Gloucester City Council in the French Renaissance style.

On the first floor, French doors flanked by Ionic columns lead onto a stone-balustraded balcony. In the attic storey, there are three central bays, and in each bay a circular window framed by boldly sculpted putti. A putto is a figure in a work of art depicted as a chubby male child, usually nude and sometimes winged. In this instance the putti are clothed and winged. Putti are commonly confused with, yet are completely unrelated to, cherubim.

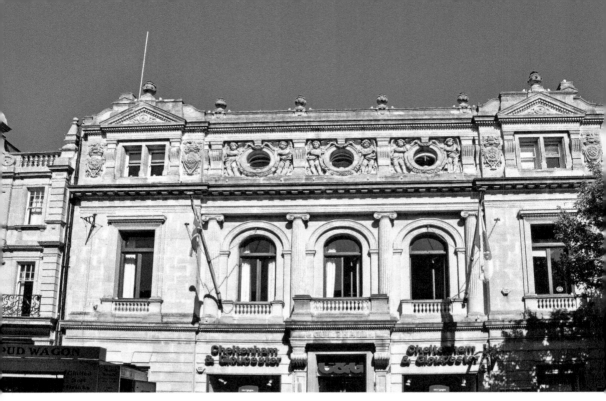

Above: The Guildhall on Eastgate Street, built in the French Renaissance style.

Below: The six putti, draped in cloth and winged.

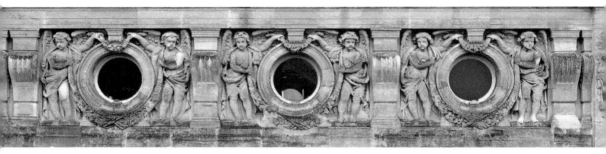

44. No. 58 Westgate Street

Another impressive building built on the corner of Westgate Street and College Street in 1890 by F. W. Waller in the Domestic Revival Style. It is three storeys high with a jettied, timber-framed attic. Built of red brick in English bond with red terracotta and stone details, it has above the entrance door on the corner of the building, at first floor-level, a quadrant corner embellished with a cartouche in an elaborately moulded panel, decorated with a floral motif in relief.

The architect, Waller, exhibited a perspective drawing of these buildings in the 1894 Royal Academy Exhibition.

Marking the entrance to the cathedral from Westgate Street, this building is designed in the Domestic Revival Manner. It has a metal plaque on the side of the building, which reads: 'In 1890 the street was widened from 10' 9", the buildings on the eastern side were afterwards erected by the Gloucester Cathedral Approaches Co Ltd involving a sacrifice of 10,000. F W Waller Archt.'

45. No. 19 Eastgate Street

The Lloyds Bank building has a symmetrical front of five bays built with red brick, granite ashlar and terracotta details. Built in 1898 in the Northern Renaissance style by F. W. Waller and Son, it is a fine example of a provincial architect's work in this style.

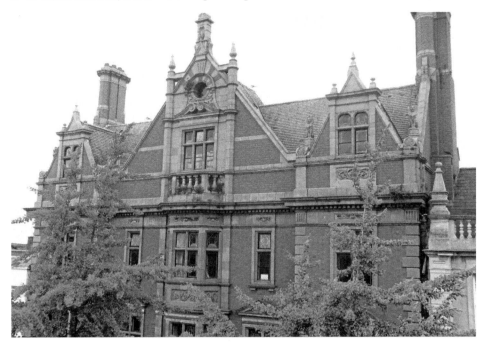

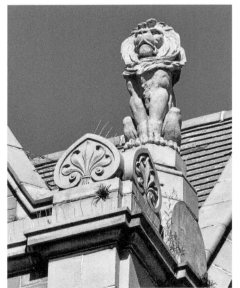

Above: Substantial red-brick building in Eastgate Street, now Lloyds Bank.

Left: A close up of the lion pedestal on top of No. 19 Eastgate Street.

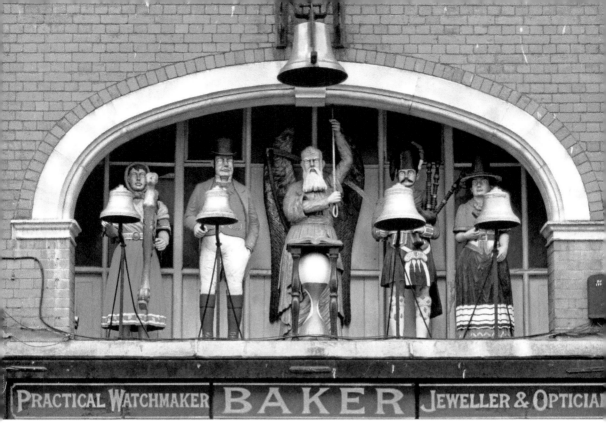

The iconic mechanical clock, outside Baker's the jewellers, still in working order.

46. No. 5 Southgate Street, G. A. Baker & Son, Jewellers

Built in 1904, this building is famous for the mechanical clock on the outside. There is a fine, well-preserved, original shopfront with large windows of plate glass, set in a cast-iron frame of colonnettes. The fascia is inscribed in the centre with the word 'BAKER', to the left with 'Practical Watchmaker' and to the right 'Jeweller & Optician' in gilt lettering.

The clock was made by Niehus Brothers of Bristol. It has five life-sized automata figures striking bells on the hours and quarters, which stand within the arched recess on the first floor. In the centre is Father Time with an hourglass, to his right John Bull and a Welshwoman, and to his left a Scotsman and an Irishwoman. Above them, on the crown of the arch, a decorative cast-iron cantilever bracket supports a clock crowned by a brass finial, and a larger bell hangs from the bracket.

47. Debenhams, Kings Square

In 1889 a local draper called John R. Pope started a drapery business in Northgate Street. The business prospered and by the 1920s it had been acquired by the Drapery Trust, which would later become Debenhams Ltd.

Above: Formerly, the Bon Marché
store in Gloucester, now Debenhams.

Left: The view of Debenhams from
Kings Square.

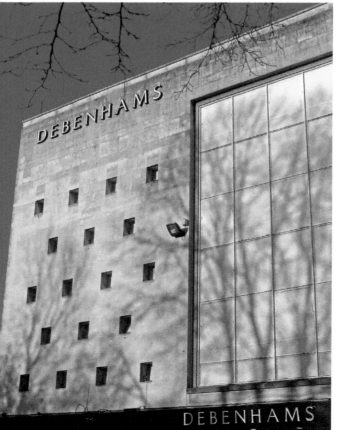

The Debenham's store today represents three phases of building. Built on the site of the original Bon Marché store, which had been in existence since at least 1836, it was described as 'modern shop premises substantially built in 1909 and 1914 of red and white glazed tiles'. Plans were drawn up in 1904 by local architect Harry A. Daucey for alterations to the Bon Marché store. The remains of this building can be seen in Northgate Street. It is of traditional brick construction with the date 1904 clearly seen on the frontage. In 1929 the building underwent 'extensive re-building operations'. This period of building typifies building styles of the inter-war period. The art deco detailing is picked out in ashlar blocks of Portland stone and at one time had the words 'Bon Marché' next to the clock tower, although they are no longer visible.

48. Nos 44–50 Eastgate Street, Argos Building

This art deco building replaced a magnificent Gothic building belonging to the Co-operative Society. It was demolished to make way for the present building. Designed by local architect William Leah in 1929 for the Gloucester Co-operative Society Ltd, this building stands on the corner of Eastgate Street and Brunswick Road. The original design included the words 'Gloucester Co-operative Society' below the clock tower, but these words do not appear on the present building.

William Leah also designed the Theatre de Luxe in Northgate Street, which was demolished in 1959.

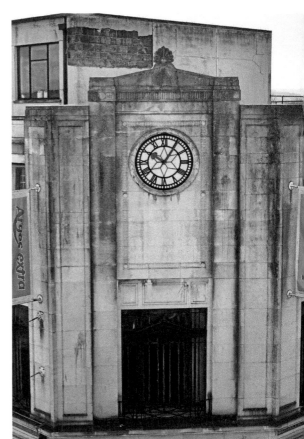

The art deco building on the corner of Eastgate Street, showing the clock.

49. The Regal

The construction of the Regal cinema building began in 1939 to the design of Associated British Pictures Corporation's in-house architect William Riddell Glen. Building stopped when the Second World War broke out; it was not until 1956, when building restrictions were lifted, that the building was finally completed to a design by ABC's in-house architect W. R. Farrow and his assistant K. Smith.

It was built in a semi-classical design with a Bath stone frontage and a plinth of Portland stone offering clean and simple lines. The entrance was described as 'a battery of armour-plate glass doors' affording 'an open and interesting view of the interior from the street'.

Taken from the commemorative brochure, the building 'was planned [so] that the theatre and architecture should be a credit to the town [sic] with its beautiful Cathedral and environs'.

It was built with 'the very latest in cinema and stage construction and techniques' of the time including widescreen, CinemaScope, Vistavision and stereoscopic pictures with improved Westrex sound systems. It was also built to allow live stage shows as well as being a cinema. G. McFarlane and P. Turner were responsible for the interior decor. The proscenium curtains were made of heavy oyster grey velour and the screen curtains of lustrous satin in a mushroom colour. The carpets were of high-grade Wilton manufacture in a red and black pattern.

The Regal in the 1960s when it was still a cinema, with the now defunct Wimpy Bar on the left.

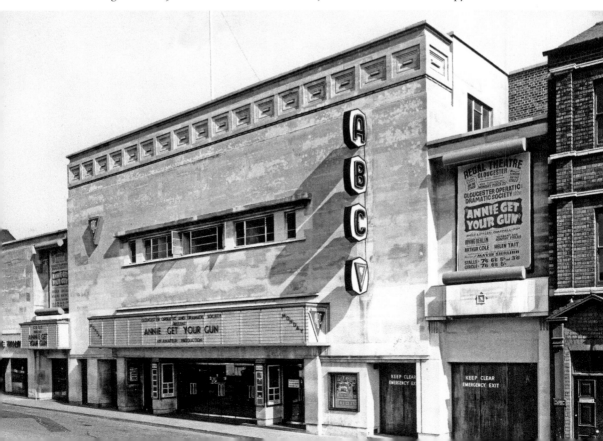

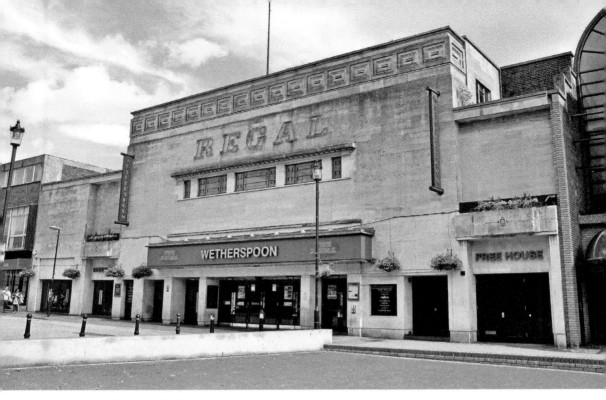

The Regal, now a Wetherspoon's pub.

On 19 March 1956, a grand opening ceremony was held, and Hubert Selby performed on the Hammond electric organ.

In 1958 further plans to extend the cinema were drawn up by the in-house architect C. J. Foster to include dressing rooms.

Famously, on 18 March 1963, as part of their UK tour with Tommy Roe and Chris Montez, the Beatles gave their only live appearance here in Gloucester.

Renamed the Cannon in 1988, the cinema closed two years later. It is now owned and run by the Wetherspoon's pub chain. During the redevelopment works in 1995, contractors were knocking down the old dressing rooms and stage area when they discovered the remains of a human jaw bone, thought to be several hundred years old. It is believed that the cinema was built on the site of an ancient burial ground.

50. Vinings Restaurant, Gloucester Docks

When Crest Nicholson were refurbishing the Grade II-listed warehouses at the docks in Gloucester, architects coombes : everitt, were given the brief to create a new restaurant adjacent to the nineteenth-century Vinings warehouse. They were keen to develop a structure that was in keeping with the industrial heritage of the site whilst still having a contemporary approach to design. The structure also needed to be of a scale and appearance that could respond to the surrounding warehouses without being of an equal scale. The front of the building was constructed using Corten steel, while the rear has a freeform elevation and was fully glazed addressing an external dining area.

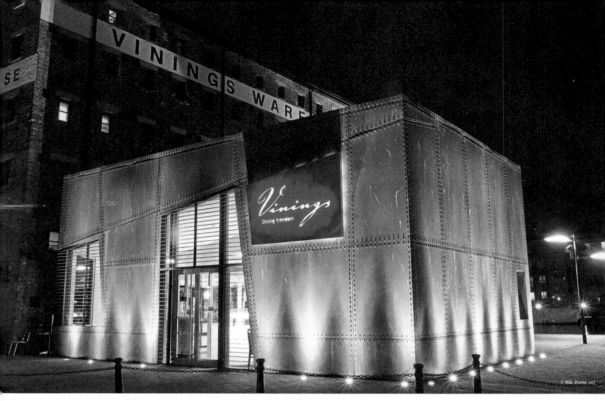

Above: A view of the 'rusty box' lit up at night.

Below: The rear of Vinings with the sweeping wave-shaped glass.

The Corten steel plates, riveted together, designed to blend in with the existing brick built warehouses.

In time, Corten steel develops a rusted finish, which has a similar colour and tone to that of the existing brick warehouses, giving it the nickname of 'rusty box'.

The restaurant, Vinings, now operates out of the award-winning 'rusty box' extension to the warehouse, complete with a sweeping, wave-shaped glass wall overlooking the main basin and tall ships boatyard.

The scheme was completed in the autumn of 2004 and was awarded a Civic Trust Award in 2005.

A Note on Listed Building Status

If a building is considered by the Secretary of State for Culture, Media and Sport to be of special architectural or historic interest it will be included in a list of such buildings. The designation regime is set out in the Planning (Listed Buildings and Conservation Areas) Act 1990. As of 2016, there were 376,470 listed buildings entries in England. Listed buildings are classified into three grades:

> Grade I buildings are of exceptional interest. Just 2.5 per cent of listed buildings are classed as Grade I.
> Grade II* buildings are particularly important buildings of more than special interest. 5.5 per cent of listed buildings are Grade II*.
> Grade II buildings are of special interest, warranting every effort to preserve them. 92 per cent of all listed buildings are in this class.

Architectural Interest

To be of special architectural interest, a building must be of importance in its architectural design, decoration or craftsmanship; special interest may also apply to nationally important examples of particular building types and techniques (for example, buildings displaying technological innovation or virtuosity) and significant plan forms.

Historic Interest

To be of special historic interest, a building must illustrate important aspects of the nation's social, economic, cultural, or military history and/or have close historical associations with nationally important people. There should normally be some quality of interest in the physical fabric of the building itself to justify the statutory protection afforded by listing.